C A N A D A

Minot G N Devils Lake
dive SULLYS HILL
N DAK G N N P
N P
ST P Jamestown Fargo

S DAK C M & ST P
Rapid City C AND NW NW C M
WIN NW C B & NW
Hot Springs NA C M & ST P C & NW
C AND NW N Y C & NW ST P Milwaukee
heyenne C B NW C & NW & ST P
NEB C M ST P
U P & Q Omaha & S FE
enver U C B AND Q C B & Q A T & Q B
P WAB M B &
Pueblo U P C Kansas City WAB ILL
A T AND M P C B & Q WAB
rinidad KANS S FE M P M P St Louis SO Cai
Wichita M P MO
C S FE S FE STL IM & S
AND S FE OKLA ARK TEN
ue K Oklahoma City S T L IM Memp
A Amarillo Sulphur PLATT HOT SPRINGS AND
Clovis G C ST L MISS
weetwater C S ST L IM & S Jacks
AND G C & S Fort Worth C & S SO
TEXAS G C & S LA
S P Houston S P
San Antonio

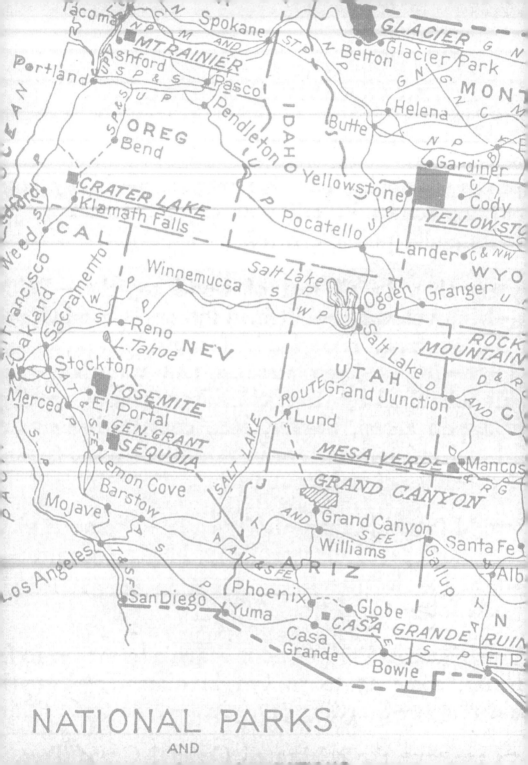

NATIONAL PARKS

AND

SEE AMERICA

SEE AMERICA

A Celebration of Our National Parks & Treasured Sites

———

Illustrated by the Artists of

CREATIVE★ACTION★NETWORK

CHRONICLE BOOKS

SAN FRANCISCO

Library of Congress Cataloging-in-Publication Data

Title: See America : a celebration of our national parks & treasured sites /
 illustrated by the artists of Creative Action Network.
Description: San Francisco : Chronicle Books, 2016.
Identifiers: LCCN 2016000615 | ISBN 9781452148984 (alk. paper)
Subjects: LCSH: Travel posters--21st century--Themes, motives. | National
 parks and reserves--United States--Posters.
Classification: LCC NC1849.T68 S43 2016 | DDC 700/.42--dc23 LC
record available at http://lccn.loc.gov/2016000615

ISBN: 978-1-4521-4898-4

Manufactured in China

MIX
Paper from
responsible sources
FSC
www.fsc.org FSC™ C008047

10 9 8 7 6 5 4 3 2

Book design by Aaron Perry-Zucker
Cover illustration by Jon Cain

1% of the sale of this book will support National Parks Conservation Association through 2017. Each artist featured received a portion of the proceeds from each sale.

Chronicle Books LLC
680 Second Street
San Francisco, California 94107
www.chroniclebooks.com

"There is nothing so American as our national parks. The scenery and the wildlife are native. The fundamental idea behind the parks is native. It is, in brief, that the country belongs to the people, that it is in process of making for the enrichment of the lives of all of us. The parks stand as the outward symbol of the great human principle."

— President Franklin D. Roosevelt

CONTENTS

NATIONAL PARKS

AND

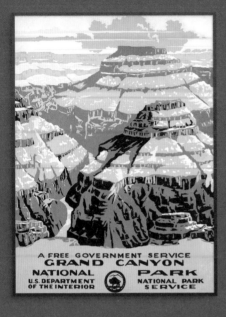

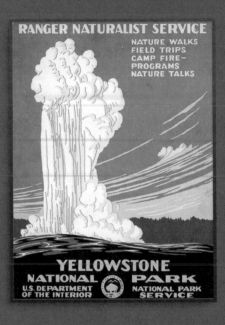

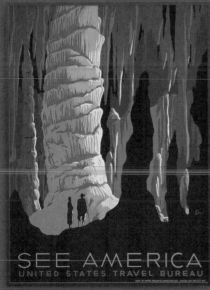

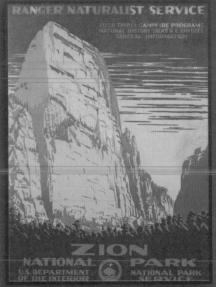

Illustrations by *Department of the Interior, National Park Service, ca. 1938*

FOREWORD

Before the National Park Service was established in 1916, artists were inspiring our nation to dream of natural spaces everyone could enjoy. William Henry Jackson's first photographs of Mammoth Hot Springs put Yellowstone on the map, and Ansel Adams's stunning photos of El Capitan and Half Dome have come to define Yosemite. The first people to persuade Congress to set aside national parks were painters like Thomas Moran and Alfred Bierstadt—artists whose enormous canvases still hang on the walls of Washington, D.C.'s museums and federal offices more than 100 years later.

Not long after our National Park Service was created in 1916, President Franklin Delano Roosevelt's New Deal and its Work Projects Administration (WPA) put the nation's artists to work creating a series of *See America* posters, educating and inspiring the wider public about our national parks. Artists of the WPA worked in government art studios, pushing the boundaries of printmaking with the cutting-edge technologies of the day, like serigraphy and color printing. They distributed their creations in schools, post offices, and other federal buildings around the country.

Many of today's artists paint with pixels and post their works to social media; a small creative community today can work at the scale and impact that used to be reserved only for government agencies. My organization, National Parks Conservation Association, the oldest and largest non-profit organization advocating for our national parks, has been fortunate enough to ride that tide thanks to our partnership with the Creative Action Network. The *See America* project has reminded Americans just how much we value these places.

The Creative Action Network has not only built a community of artists, they've helped us foster community in and around national parks. By hosting exhibits throughout the country, they've taken the powerful images off the screen and put them on the wall, where people can gather and enjoy them over a drink and a story. The *See America* project has given us an opportunity to engage young and diverse audiences—people who will play a key role in our parks' second century.

We hope the images in this book will inspire the next generation of park activists, whether that activism involves volunteering at a nearby park, writing a letter to the editor of their local paper, contacting a member of Congress, or bringing friends to a park so they can experience firsthand what talented artists have captured on these pages.

Theresa Pierno,
Chief Operating Officer
National Parks Conservation Association
Washington, D.C.

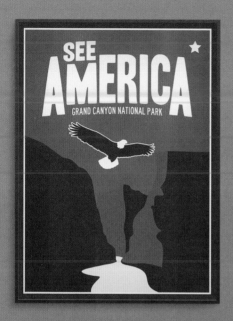

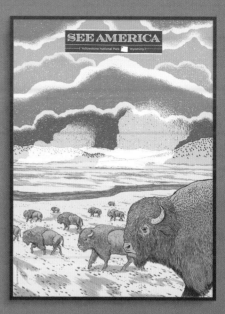

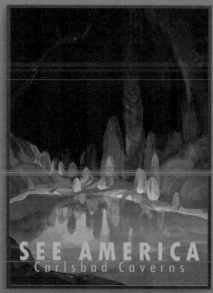

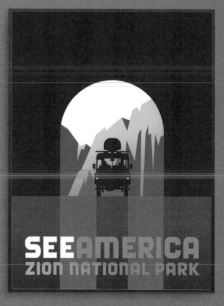

Illustrations by *Matt Brass, Brixton Doyle, Alyssa Winans, Luis Prado*

INTRODUCTION

As long there have been advocates committed to the conservation of the American landscape, there have been artists harnessing their talents for that same cause. The ongoing collaboration between creativity and conservation shaped both our physical landscape and our national identity in a virtuous cycle we set out to continue with our revival of the *See America* project.

During the Great Depression, as part of President Roosevelt's New Deal, the Work Projects Administration put the nation to work building bridges and roads, teaching in schools and libraries, constructing post offices and government buildings, and, controversially at the time, making art. The Poster Division of the WPA was one of the first U.S. government programs to directly support the arts, producing thousands of beautifully designed posters from 1936 to 1943 on a range of issues from healthcare and education to road safety. Our favorite series, the *See America* posters, were designed to get people to do just that—get out and see America, particularly all the relatively new national parks that had been established in 1916. The project put a generation of artists to work, and the bold style and sheer size of their collected works has had a lasting influence on the American aesthetic and in the minds of artists and designers today.

It is in that spirit that we partnered with the National Parks Conservation Association to revive the *See America* project for a new generation of artists, and a new generation of parks, in celebration of the 2016 centennial of the National Park Service. In 2014, we put out an open call to artists and designers around the world, inviting them to design and share posters depicting their favorite parks with the same *See America* banner used by the artists of the WPA. Anyone can contribute, and all designs are available for purchase online as posters, T-shirts, and more, to support these artists' work. At the time of this writing, we have received nearly 1,000 designs, but unfortunately could not fit all of them into this book. In this selection of 75 locations featuring some of our top designs, we have done our best to represent the wide range of diversity in our parks and the equally inspiring diversity of creative interpretations for them. To see the rest of the collection, or to contribute your own design, we encourage you to visit www.SeeAmericaProject.com.

Like the WPA before us, we hope the *See America* project will inspire a new generation to visit, preserve, and protect our country's natural treasures and shared cultural heritage. Thank you to all of the artists who have contributed their time and their talents to the *See America* project, and to all of the tireless advocates who protect and cherish our parks.

Aaron Perry-Zucker and Max Slavkin
Cofounders
Creative Action Network
San Francisco

WASHINGTON MONUMENT

Established: 1848 — Washington, D.C.

In 1833, the Washington National Monument Society formed to build a monument to America's first president. When the 555-foot tall Egyptian-style obelisk opened in 1888, it stood as the world's tallest structure, a title it kept for only a year when the Eiffel Tower was completed in Paris, France. After a closure following a magnitude 5.8 earthquake in 2011 that caused more than 150 cracks in the structure, the monument was restored and reopened in 2014.

POTOMAC

Illustration by *Brandon Kish*

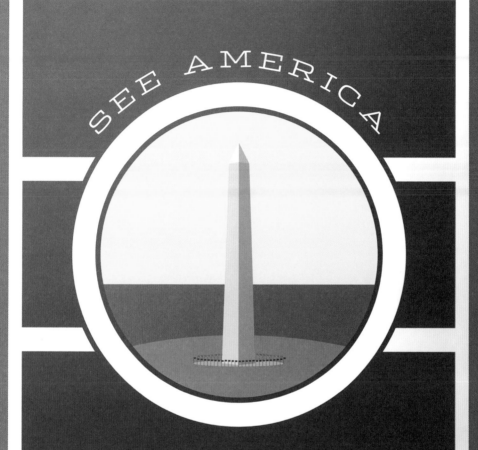

SEE AMERICA

Washington Monument

WASHINGTON DC

YOSEMITE NATIONAL PARK

Established: 1864 — California

On June 30, 1864, President Abraham Lincoln signed into law the Yosemite Grant, America's very first bill setting aside land for preservation and public use. John Muir lobbied Congress to protect the land from overgrazing and logging of Sequoia trees, and in 1890, President Benjamin Harrison signed the legislation creating America's third national park. In 1903, President Theodore Roosevelt took control of the park away from California and gave it to the federal government. Until the National Park Service was created in 1916, the park was protected by the Buffalo Soldiers, the all-black army regiments that served as America's first park rangers.

Illustrations by *Alyssa Winans, Nikkolas Smith, Naomi Sloman, Monica Alisse*

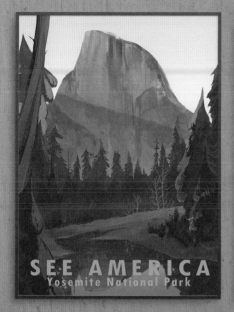

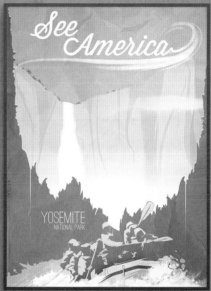

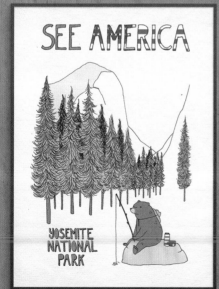

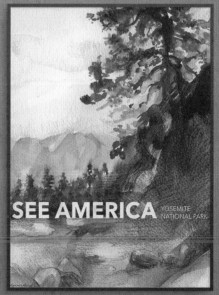

YELLOWSTONE NATIONAL PARK

Established: 1872 — Wyoming/Montana/Idaho

The first national park in the country, Yellowstone was established by President Ulysses S. Grant on March 1, 1872. Early visitors were drawn by the park's most predictable geyser, Old Faithful, which erupts every 63 minutes, shooting up to 8,400 gallons of boiling water nearly 150 feet in the air. Yellowstone remains the largest megafauna location in the United States and is home to grizzly bears, elk, wolves, and the largest bison herd in the country.

Illustration by ***Brixton Doyle***

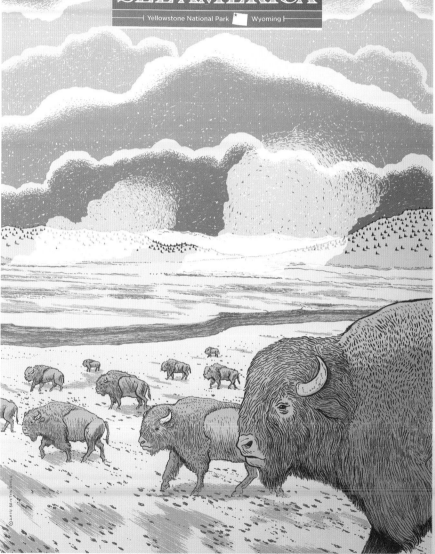

ANTIETAM NATIONAL BATTLEFIELD

Established: 1890 — Maryland

On September 17, 1862, General Robert E. Lee led his Confederate troops across Union lines in what would become the bloodiest single day in American history. Nearly 23,000 soldiers were killed, wounded, or missing in the first major battle on Union soil. Just five days after the Union victory at Antietam, President Lincoln gave the Emancipation Proclamation. The battlefield was first protected by the War Department at the urging of local citizens and Civil War veterans groups in 1890, and listed on the National Register of Historic Places in 1966.

Illustration by *Frank Cervantez*

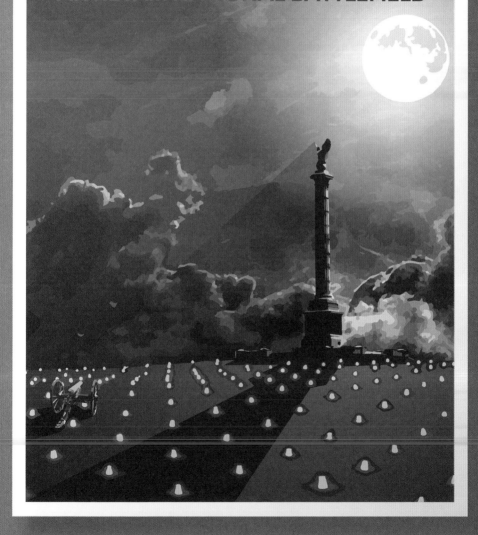

SEQUOIA AND KINGS CANYON NATIONAL PARKS

Established: 1890 — California

In order to protect California's giant sequoia trees from logging, President Benjamin Harrison established Sequoia National Park as our second national park in 1890. Five of the ten largest trees in the world can be found in the park, including the famous General Sherman tree which, by volume, is the largest living single stem tree on earth. The highest point in the contiguous 48 states, Mount Whitney, also sits in Sequoia National Park, rising 14,505 feet above sea level. Sequoia National Park and Kings Canyon National Park have been jointly administered since 1943.

Illustration by *Luis Prado*

GETTYSBURG NATIONAL MILITARY PARK

Established: 1895 — Pennsylvania

Immortalized in President Lincoln's Gettysburg Address, the Battle of Gettysburg is remembered as a key tipping point in the Civil War and the end of General Lee's second invasion of the north. In 1864, just a year after the battle, local citizens came together to create the Gettysburg Battlefield Memorial Association, and 30 years later, those citizens transferred their land to the federal government to create the National Military Park. Gettysburg today is home to 43,000 Civil War artifacts and boasts more trees and wooded land now than it did the day of the battle in 1863.

Illustrations by *Matt Brass*

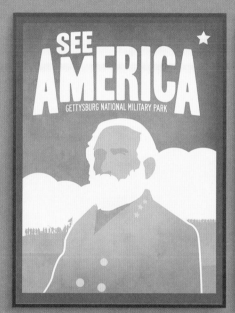
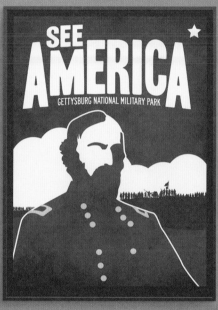

MOUNT RAINIER NATIONAL PARK

Established: 1899 — Washington

In 1888, John Muir was one of the first climbers to record an ascent to the summit of Mount Rainier, a defining experience in his commitment to the creation and protection of wilderness areas. Muir's Sierra Club, the National Geographic Society, and many others pushed President McKinley to establish Mount Rainier as our fifth national park in 1899. It remains an active volcano and is the highest point in the Cascade Range.

Illustration by *Vanessa Rosales*

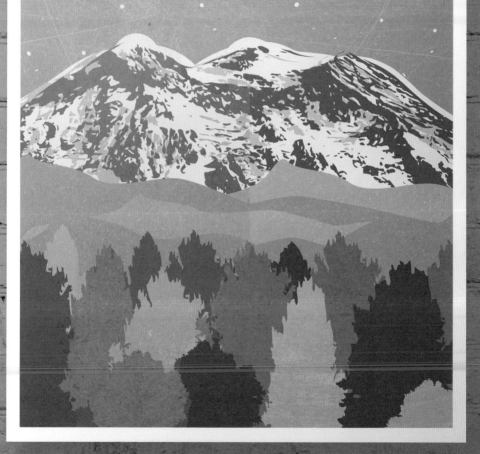

DEVILS TOWER
NATIONAL MONUMENT

Established: 1906 — Wyoming

Devils Tower is the first of our National Monuments, established by President Theodore Roosevelt in 1906 with the brand new authority granted to him by the Antiquities Act, which for the first time allowed the President to create national monuments without the congressional approval required to establish national parks. The oldest rocks in area are roughly 200 million years old, and for thousands of years the 1,267-foot formation has been a sacred place for Native Americans. Just one percent of today's visitors climb the tower, but many more come to the park inspired by its appearance in the 1977 movie *Close Encounters of the Third Kind*.

Illustration by **Brixton Doyle**

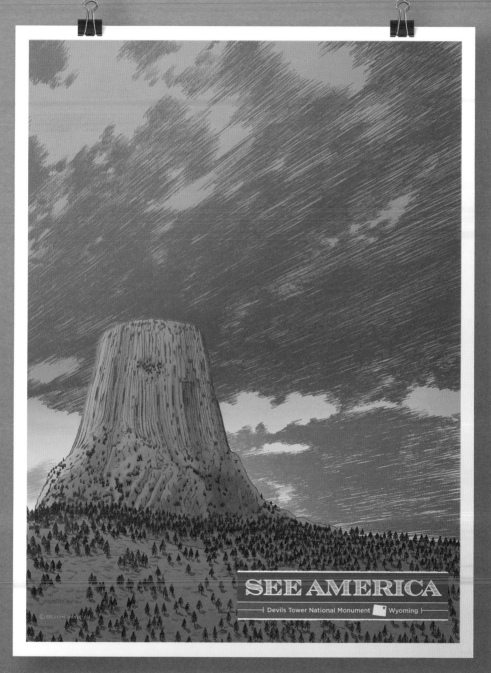

CHACO CULTURE NATIONAL HISTORICAL PARK

Established: 1907 — New Mexico

Between 850 and 1250 A.D., the Pueblo people built huge stone structures in the center of their grand civilization, now the American Southwest. As late at the nineteenth century, the 15 tallest buildings in North America were those left by the Pueblo people in Chaco Canyon. The remote area and ancient ruins were largely untouched when President Theodore Roosevelt established Chaco Canyon National Monument in 1907. Further research by the National Geographic Society, the University of New Mexico, and others led to the expansion and redesignation of the park as Chaco Culture National Historical Park in 1980.

Illustration by *Annie Riker*

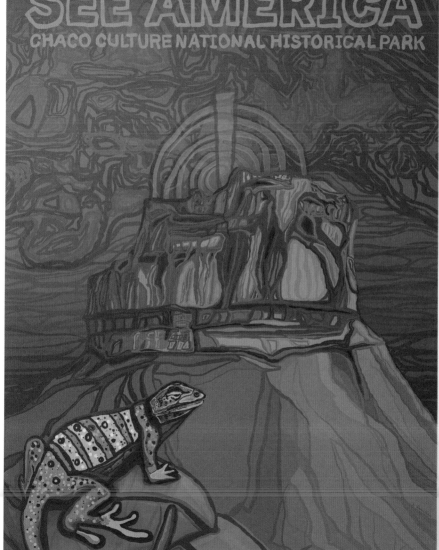

MUIR WOODS NATIONAL MONUMENT

Established: 1908 — California

Redwood trees have grown along the Pacific Coast for at least 150 million years, but by the early 20th century, most had been cut down. To protect one of the last old-growth redwood forests, Congressman William Kent and his wife, Elizabeth, bought the land Muir Woods now sits on for $45,000 and in 1908, donated it to the federal government. In 1945, delegates from around the world took a break from writing the first UN charter in San Francisco to attend a memorial for President Franklin Roosevelt in Muir Woods. In 2014, Roosevelt's great-granddaughter Shayna contributed this design to the *See America* project.

Illustration by **Shayna Roosevelt**

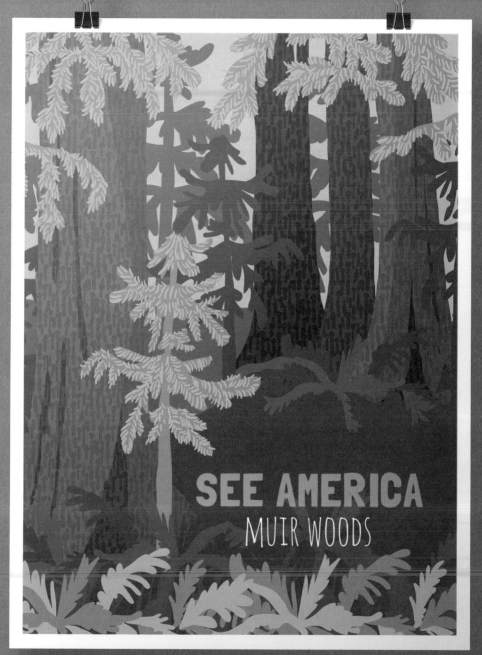

OLYMPIC NATIONAL PARK

Established: 1909 — Washington

After leading the first well-documented expeditions of the Olympic Mountains in 1885 and 1890, Lt. Joseph P. O'Neil began advocating for the creation of a national park in the area. With so many settlers moving westward, the Olympic elk—now called Roosevelt elk—population was being decimated, and largely to protect them, President Theodore Roosevelt created Mount Olympus National Monument in 1909. In 1938, President Franklin Roosevelt designated it a national park. Olympic's nearly one million acres encompass a unique diversity of wilderness, from shoreline to forested valleys to snowcapped peaks.

Illustration by *Corbet Curfman*

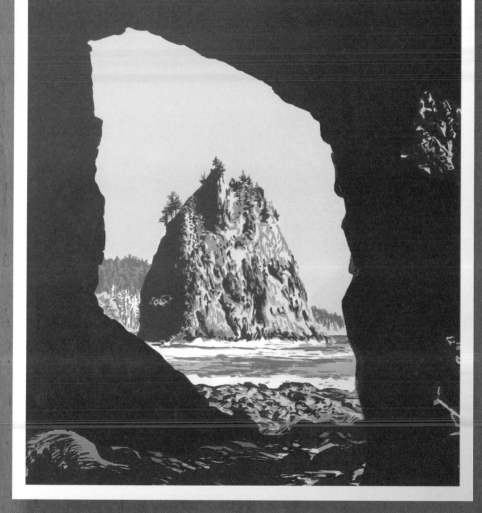

ZION NATIONAL PARK

Established: 1909 — Utah

The area has been home to humans for nearly 12,000 years, providing a rare combination of beauty in the desert with a river to water crops. Mormon settlers were drawn to Zion beginning in 1847, and in 1909, President William Howard Taft set aside the area for protection as Mukunutuweap National Monument. The name only lasted until 1918, when the director of the brand new National Park Service changed the name to Zion. The monument was established as a national park in 1919. In 2009, President Barack Obama signed legislation setting aside an additional 125,000 acres as the Zion Wilderness area within the park.

Illustration by *Luis Prado*

GLACIER NATIONAL PARK

Established: 1910 — Montana

The Lewis and Clark expedition came within 50 miles of what would become Glacier National Park, and many European fur trappers and miners followed soon after. When the Great Northern Railway opened in 1891, new visitors joined the growing movement to set the park aside for public protection. Local lobbying pushed President Taft to establish Glacier National Park in 1910. The park borders Waterton Lakes National Park in Canada, and together the two were designated as the world's first International Peace Park in 1932.

Illustration by *Matt Brass*

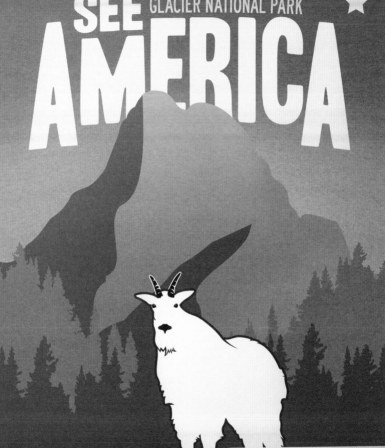

LINCOLN MEMORIAL
NATIONAL MONUMENT

Established: 1911 — Washington, D.C.

Public demand for a memorial to President Lincoln began immediately after his assassination in 1865, but it took nearly 50 years of fundraising and debating in Congress for construction on the monument to begin. The memorial opened in 1922 with President Lincoln's only surviving son, Robert Todd Lincoln, in attendance. The monument holds a unique place in our culture, from the iconic backs of the five-dollar bill and the penny, to the site of Dr. Martin Luther King, Jr's "I Have a Dream" speech in 1963.

Illustration by *Luis Prado*

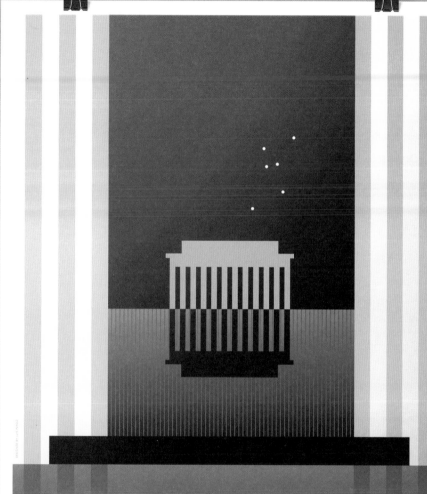

SEEAMERICA

LINCOLN MEMORIAL

ROCKY MOUNTAIN NATIONAL PARK

Established: 1915 — Colorado

The U.S. government acquired the land that would become Rocky Mountain National Park with the Louisiana Purchase of 1803. Extreme weather and rugged terrain made farming difficult, but that didn't stop miners, trappers, and tourists from visiting in increasing numbers. Local citizens began advocating for protection of the land in 1909, and one early leader, naturalist Enos Mills, seeing victory coming soon, proclaimed, "In years to come when I am asleep beneath the pines, thousands of families will find rest and hope in this park."

Illustration by *Daisy Patton*

See America

Rocky Mountain National Park

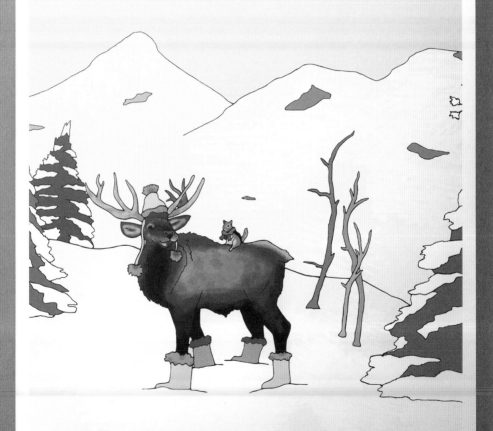

DINOSAUR NATIONAL MONUMENT

Established: 1915 — Colorado

In 1909, while looking for large mammal fossils, a paleontologist working for the Carnegie Museum of National History discovered thousands of dinosaur fossils near the border of Colorado and Utah. President Wilson established Dinosaur National Monument soon after, protecting both the fossils and the Native American petroglyphs and artifacts in the area. The park was expanded as part of the New Deal in the 1930s, and in 2011, the visitor center and exhibit hall reopened after nearly six years of renovations.

Illustration by *Darrell Stevens*

SEE AMERICA

DINOSAUR NATIONAL MONUMENT

HALEAKALĀ NATIONAL PARK

Established: 1916 — Hawaii

Haleakalā is Hawaiian for "house of the sun," and is also the name for the park's dormant volcano, which last erupted roughly 500 years ago. The park was originally part of Hawai'i National Park when it was created in 1916, but it split with what became Hawai'i Volcanoes National Park in 1961. Today Haleakalā National Park is home to more endangered species than any other park in the National Park Service.

Illustration by *Roberlan Borges*

SEE AMERICA

Haleakalā National Park

◂ HAWAII ▸

HAWAI'I VOLCANOES NATIONAL PARK

Established: 1916 — Hawaii

People have lived on the Hawaiian Islands for at least a thousand years, and the first Europeans to document their visit came in 1823. The volcanoes became a tourist destination by the 1840s, and when local interests successfully lobbied for the creation of the park in 1916, it became the first National Park in a U.S. territory, 43 years before Hawaii became a state. In 1961, Hawai'i National Park split into two parks, Haleakalā National Park and Hawai'i Volcanoes National Park, and in 2004, President George W. Bush expanded the park. Volcanoes in the region continue to erupt, with one eruption as recent as 2008.

Illustration by *Alyssa Winans*

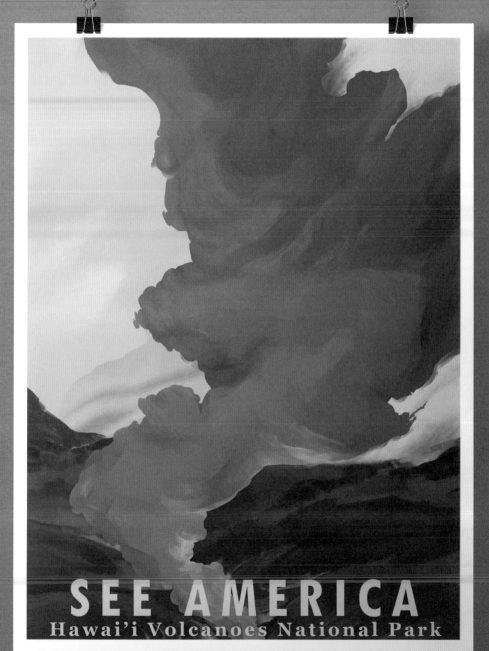

SEE AMERICA

Hawai'i Volcanoes National Park

DENALI NATIONAL PARK AND PRESERVE

Established: 1917 — Alaska

The park was originally named Mount McKinley National Park when it was created in 1917, 21 years after a gold prospector named the highest peak in North America for then–presidential candidate William McKinley. In 1980, the name was changed back to the indigenous name for the mountain, Denali, meaning "high one," and in 2015, President Obama changed the name of the mountain itself back to Denali. 400,000 people visit the park's 6 million acres each year, where the lowest recorded temperature is -55° F, and over 600 earthquakes occur each year.

Illustration by *Jenn Brigham*

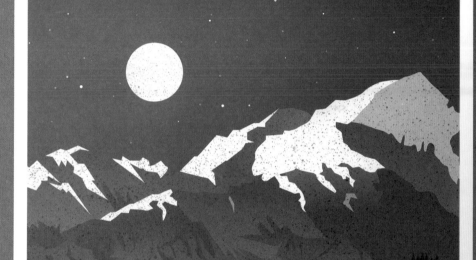

SEE AMERICA

WELCOME TO
DENALI NATIONAL PARK AND PRESERVE, ALASKA

KATMAI NATIONAL PARK AND PRESERVE

Established: 1918 — Alaska

After heavy volcanic eruptions in 1912, the National Geographic Society began sending expeditions to explore the area around Mount Katmai in 1915. Articles in the famous magazine brought the region, the Valley of Ten Thousand Smokes, the volcanoes, and the bears to the imagination of Americans everywhere, at the same time legislation to establish Mount McKinley National Park was pending in Washington. The park was expanded several times after President Wilson established Katmai National Monument in 1918, eventually becoming a National Park and Preserve in 1980.

Illustration by *Joshua Sierra*

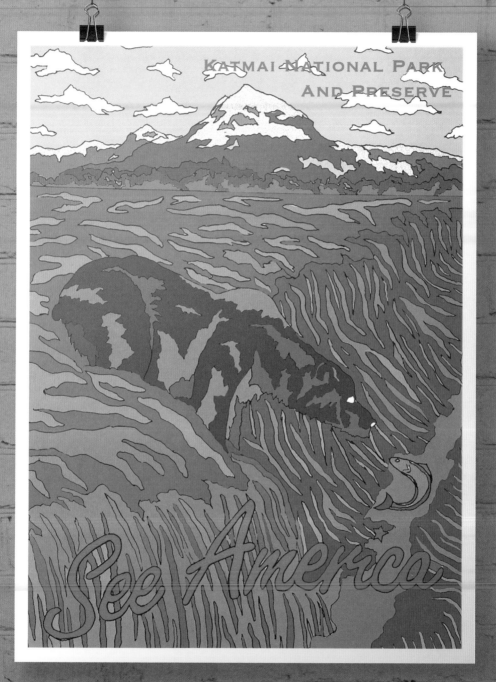

GRAND CANYON NATIONAL PARK

Established: 1919 — Arizona

The Colorado River has been carving the canyon through the desert for the last 40 million years, and when President Theodore Roosevelt visited in 1903, he pronounced: "The Grand Canyon fills me with awe. . . . Let this great wonder of nature remain as it now is. . . . You cannot improve on it. But what you can do is to keep it for your children, your children's children, and all who come after you, as the one great sight which every American should see." When Grand Canyon National Park was established 16 years later it had 44,173 visitors; today over 5 million people visit each year.

Illustrations by *J. D. Reeves* and *Matt Brass*

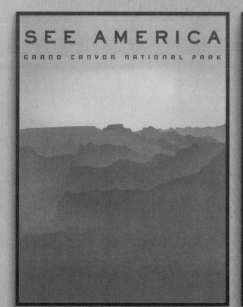

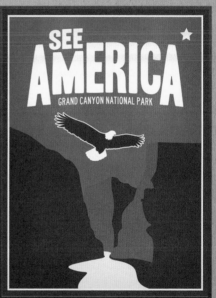

ALLEGHENY NATIONAL FOREST

Established: 1923 — Pennsylvania

When Allegheny National Forest was established in 1923, so many of its trees had been cut down to fuel growth in the West and in eastern cities that neighbors called the area the "Allegheny brush-patch." The National Forest that has flourished since provides not just a natural habitat for wildlife and recreation for visitors, but timber for industry as well, and is one of the least densely populated areas east of the Mississippi River.

Illustration by *Don Henderson*

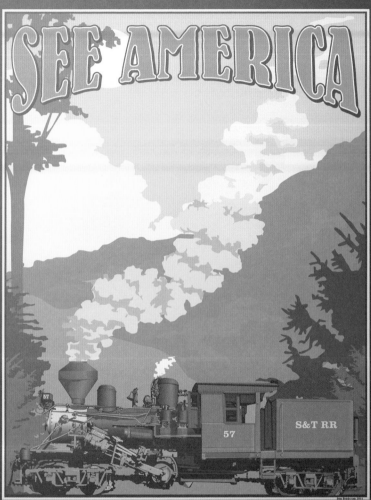

CARLSBAD CAVERNS NATIONAL PARK

Established: 1923 — New Mexico

In 1898, 16-year-old Jim White, a future park ranger, discovered what became Carlsbad Caverns, remarking that "any hole in the ground which could house such a gigantic army of bats must be a whale of a big cave." His advocacy, along with photos of the caverns featured in the *New York Times* in the spring of 1923, led to the establishment of Carlsbad Cave National Monument later that year, eventually becoming a national park in 1930. The 119 known caves that made up an inland sea reef 250 million years ago are still being explored, with new caves discovered as recently as 2013.

Illustration by *Alyssa Winans*

STATUE OF LIBERTY NATIONAL MONUMENT

Established: 1924 — New York/New Jersey

Located on one of three "Oyster Islands" in New York harbor, Liberty Island was inhabited by Native Americans long before Henry Hudson landed in the harbor in 1609. The island served as a fort in the Civil War, and after the Union victory, French intellectual Edouard de Laboulaye proposed giving the United States a gift representing liberty to mark the young nation's centennial. Designed in part by Alexandre-Gustave Eiffel, the statue opened in 1886, just in time for a wave of new immigrants to America to be welcomed by Lady Liberty.

Illustrations by *Don Henderson, Marlena Buczek Smith, David Garcia, Shane Henderson*

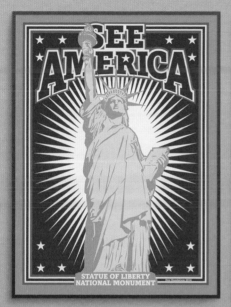

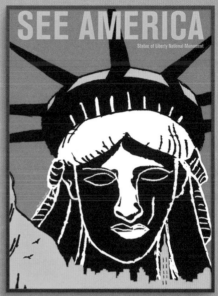

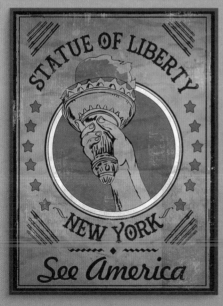

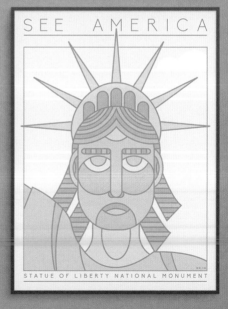

ELLIS ISLAND NATIONAL MONUMENT

Established: 1924 — New York/New Jersey

When the federal government took control of the land in 1890 to build America's first federal immigration station, Ellis Island was much smaller in area. But it was built up largely with landfill from the construction of New York City's subway tunnels to double its original size. Between 1905 and 1914 an average of one million immigrants per year came to the U.S., and today about one third of America's population can trace their family history back to someone entering through Ellis Island.

Illustration by *Luis Prado*

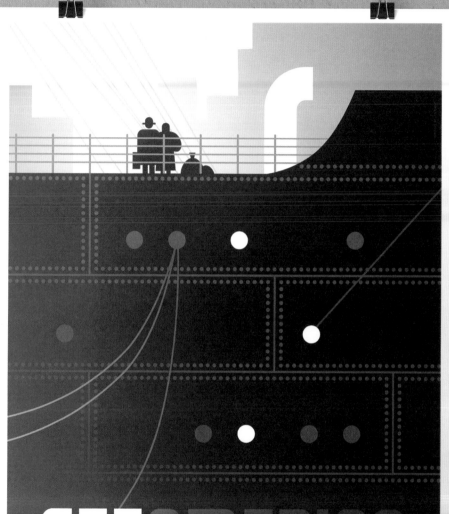

SEEAMERICA
ELLIS ISLAND NATIONAL MONUMENT

MOUNT RUSHMORE
NATIONAL MEMORIAL

Established: 1925 — South Dakota

Conceived as a way to boost tourism to South Dakota, the 60-foot-tall carvings of four U.S. Presidents were blasted and carved into Mount Rushmore by 400 workers under the direction of Gutzon Borglum between 1927 and 1941. Borglum, who had just been working on a Confederate memorial of Robert E. Lee, described the purpose of his work: "... to communicate the founding, expansion, preservation, and unification of the United States." Over 90 percent of Mount Rushmore was sculpted using dynamite, taking 450,000 tons of rock from the mountain.

Illustration by *Wedha Abdul Rasyid*

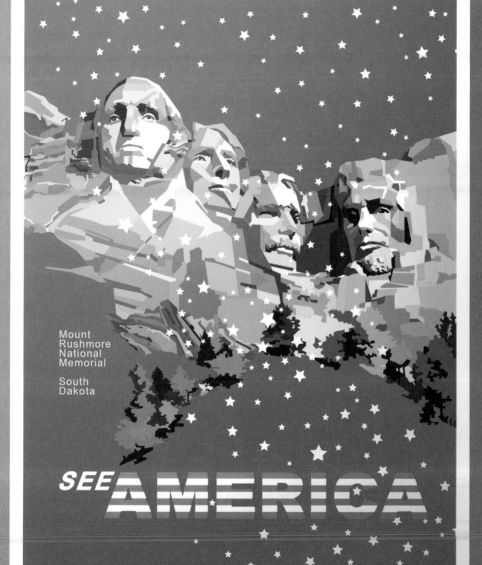

Mount
Rushmore
National
Memorial

South
Dakota

SEE AMERICA

Inspired by the photo seen in google

GREAT SMOKY MOUNTAINS NATIONAL PARK

Established: 1926 — Tennessee/North Carolina

First authorized by Congress in 1926 and dedicated by Franklin Roosevelt in 1940, Great Smoky Mountains National Park was the first national park to receive federal funding and one of the first national parks in the East. The park sits in the Blue Ridge division of the Appalachian Mountains and is home to approximately two black bears per square mile, as well as 97 historic structures from early mountain settlers. Today, Great Smoky Mountains National Park is the most visited national park in the country.

Illustration by *Jon Cain*

WRIGHT BROTHERS
NATIONAL MEMORIAL

Established: 1927 — North Carolina

Drawn by the area's steady winds, brothers and bicycle mechanics Wilbur and Orville Wright spent four years experimenting in Kitty Hawk, North Carolina until they achieved the first successful airplane flight on December 17, 1903. The memorial was completed by the War Department in 1932 with Orville in attendance at the dedication, and was transferred to the National Park Service in 1933.

Illustration by *Luis Prado*

SEE AMERICA

WRIGHT BROTHERS NATIONAL MEMORIAL

GRAND TETON NATIONAL PARK

Established: 1929 — Wyoming

In 1808, on his way back east after journeying to the Pacific Ocean as part of Lewis and Clark's Corps of Discovery, John Colter became the first explorer to see the Teton Mountains and the rugged canyons formed by glaciers. Yellowstone National Park was established just 10 miles to the north in 1872, and by the turn of the century pressure was mounting to create a separate park for the Tetons. Today, the two parks are connected by the John D. Rockefeller Memorial Parkway. They form one of the largest intact temperate ecosystems in the world.

Illustration by *Jonathan Scheele*

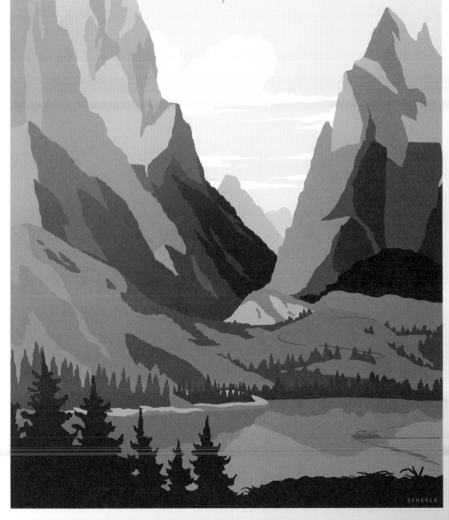

BADLANDS NATIONAL PARK

Established: 1929 — South Dakota

The Lakota people discovered rich fossils from ancient rhinos, horses, and saber-toothed cats long before settlers and paleontologists rushed into the area in the mid-19th century. Those homesteaders, with the help of their senator, lobbied for protection of the area so inhospitable the Sioux had named it "Badlands," first with the South Dakota legislature in 1909 and eventually receiving federal protection in 1939. Many settlers who had come to the area were forced out by the Dust Bowl in the 1930's. Today the visitor center is named for Ben Reifl, the first congressman from the Sioux nation.

Illustration by *Matt Brass*

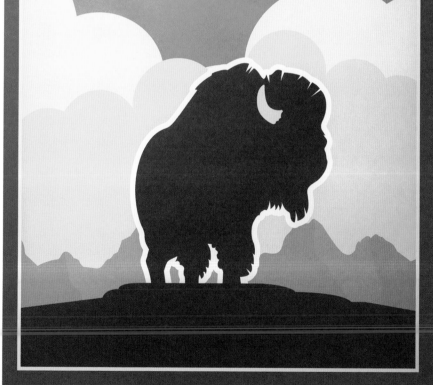

ARCHES NATIONAL PARK

Established: 1929 — Utah

The idea for Arches National Park first came from railroad employees who thought the over 2,000 natural stone arches, formed by a salt bed left from an ancient sea, would draw tourists and should be protected. When first established as a National Monument in 1929, only the stone formations themselves were included, until the area was expanded in 1939 to protect additional scenic formations. It was eventually established as a national park in 1971.

Illustration by **Kendall Nelson**

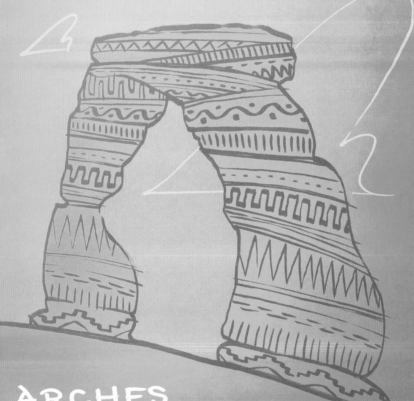

SEE AMERICA

ARCHES
NTL. PARK

DEATH VALLEY NATIONAL PARK

Established: 1933— California/Nevada

Death Valley, the hottest, driest place in North America, was given its name by a group of travelers who lost a member of their party on their way to the California Gold Rush in 1849. Tourism boomed when hotels were built in the 1920s, leading to the establishment of Death Valley National Monument in 1933 and the park's development by workers of the Civilian Conservation Corps during the Great Depression. Death Valley became a national park in 1994 and is now the largest park in the lower 48 states, with the highest recorded temperature at 134° F.

Illustration by *Braulio Amado*

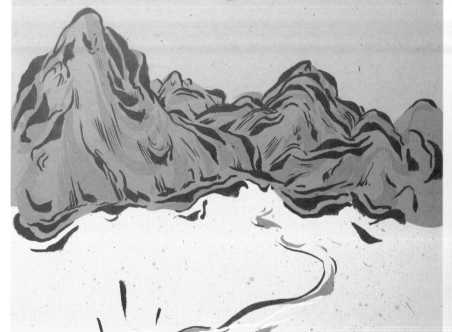

See America

Death Valley National Park

BIG BEND NATIONAL PARK

Established: 1933 — Texas

When the Mexican-American war ended in 1848, American settlers and soldiers began to explore and develop the uncharted territory on the U.S.-Mexico border. To protect the dramatic landscape from growing populations of ranchers, miners, and developers, the Texas state legislature established Texas Canyon State Park in 1933, setting aside the land that would become Big Bend National Park in 1944 for future generations. A testament to the diversity of the American Southwest, Big Bend has been claimed by six different nations over the last 500 years.

Illustration by *Aaron Bates*

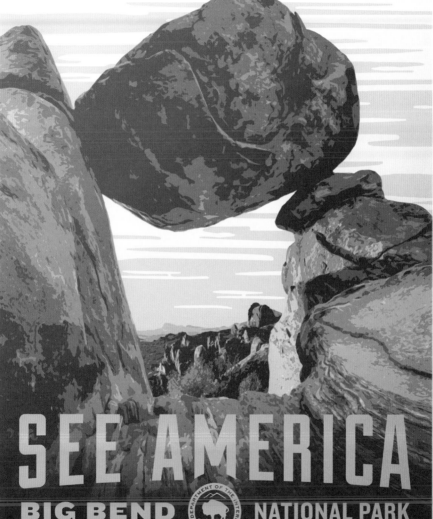

SEE AMERICA

BIG BEND NATIONAL PARK

MADE BY A·B·P

SAGUARO NATIONAL PARK

Established: 1933 — Arizona

Home to the world's largest cacti, the Sonoran desert near Tucson, Arizona, was established as Saguaro National Monument by President Hoover in 1933 during the Great Depression. The University of Arizona and other organizations continued working to protect the land from ranching and to further develop interest in Tucson, and in 1994, the area won the designation of national park. Beyond the famous Saguaro cactus, the desert is home to six species of rattlesnake, as well as gila monsters, one of two venomous lizards in the world.

Illustrations by *Jessica Gerlach (2),*
Hanna Norris, Roberlan Borges

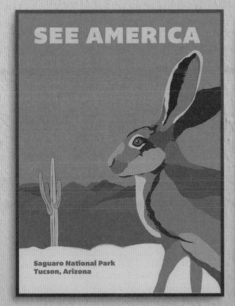

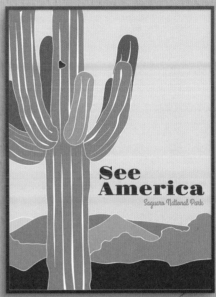

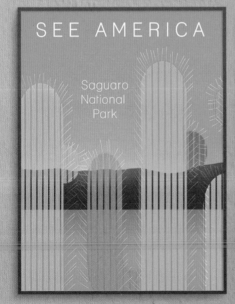

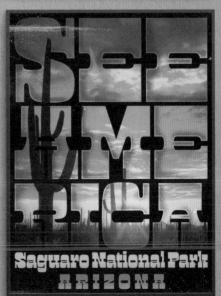

DRY TORTUGAS NATIONAL PARK

Established: 1935 — Florida

When he landed on the islands in 1513, Ponce De Leon caught 160 sea turtles and gave the Dry Tortugas their Spanish name. The U.S. bought Florida from Spain in 1819, and soon after, in 1822, plans for a naval installation began. Fort Jefferson, the largest masonry structure in the Western Hemisphere, was never completed, but was used by the army until 1888.. The area was first protected as a national monument in 1935, after hurricanes had made military use impractical. The Dry Tortugas are now the most remote and least disturbed islands and coral reefs in the Florida Keys.

Illustration by **Luis Prado**

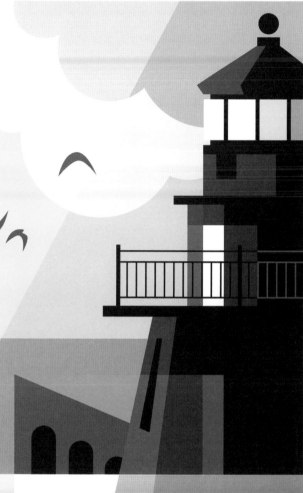

SEEAMERICA
DRY TORTUGAS NATIONAL PARK

JEFFERSON NATIONAL EXPANSION MEMORIAL

Established: 1935 — Missouri

In the 1930s, when federal officials were looking for a site for a monument to the country's third president, the city of St. Louis convinced them to build the monument there to honor Thomas Jefferson's role in opening the West. St. Louis also wanted to memorialize Dred Scott, who sued for his freedom in the Old Courthouse. The Gateway Arch, known as the "Gateway to the West," celebrates the launching of the Lewis and Clark Expedition from St. Louis and was one of the first monuments designed after World War II.

Illustration by *Shane Henderson*

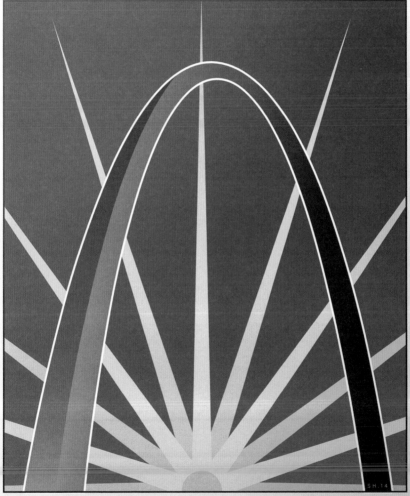
SEE AMERICA

JEFFERSON NATIONAL EXPANSION MEMORIAL

BLUE RIDGE PARKWAY

Established: 1936 — Tennessee/North Carolina

Construction began in 1935 on what was originally called the Appalachian Scenic Highway as part of President Franklin D. Roosevelt's New Deal. It took 52 years to complete construction of the highway, which at 469 miles is America's longest linear park. It was the most visited unit of the National Park System every year from 1946 to 2012, and in 2015 was featured on North Carolina's "America the Beautiful" quarter.

Illustration by *Jon Cain*

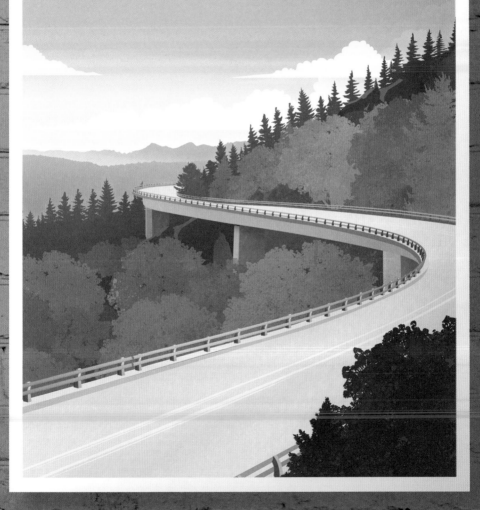

JOSHUA TREE NATIONAL PARK

Established: 1936 — California

The trees were named by Mormon settlers crossing the desert in the 19th century who saw in them the image of the biblical prophet Joshua holding his hands up to the sky. Concerned with increasing automobile traffic, Minerva Hamilton Hoyt began leading efforts to protect the deserts. In 1936, Hoyt persuaded President Roosevelt to establish Joshua Tree National Monument, which would become Joshua Tree National Park in 1994. Over 800 species of desert plants thrive in the park—so many that when legislation for a park was first proposed in the 1930's, the initial name was Desert Plants National Park.

Illustration by *Adam S. Doyle*

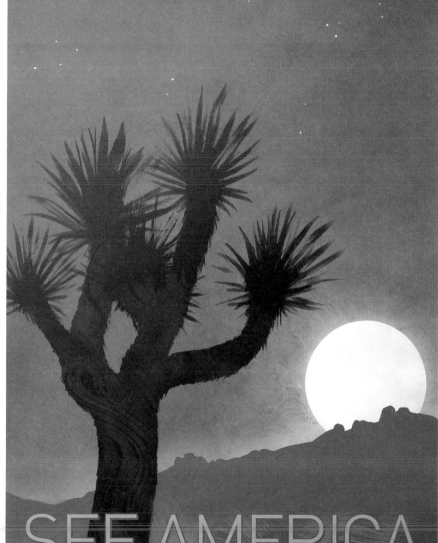

ORGAN PIPE CACTUS NATIONAL MONUMENT

Established: 1937 — Arizona

Organ Pipe Cactus National Monument was established in 1937 to preserve a piece of Sonoran desert wilderness for future generations. The park is the only place in the country where the Organ Pipe Cactus grows wild. Visitors can see buildings and structures left behind by miners and ranchers who had set settled along old Native American trading routes over 150 years ago. The park is home to the critically endangered Sonoran Pronghorn, and 95 percent of the park is designated wilderness area.

Illustration by *Adam S. Doyle*

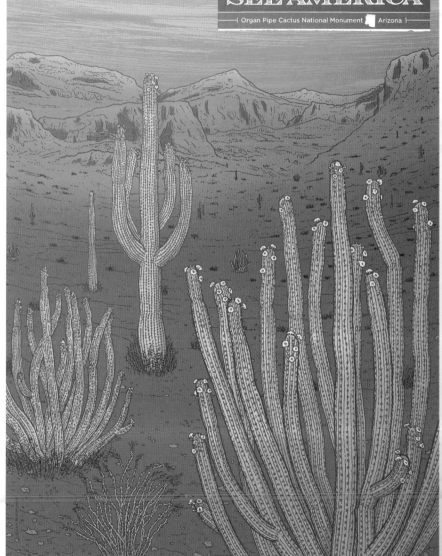

CHANNEL ISLANDS NATIONAL PARK

Established: 1938 — California

Just off the Southern California coast, the five islands that make up Channel Islands National Park are home to the oldest dated human remains in North America. The islands have been used for a wide range of purposes, from ranching, to fishing, to naval operations, to alcohol smuggling during Prohibition in the 1920s. The area was established as a National Monument in 1938. Today the park is home to 145 species found nowhere else in the world and the largest aggregation of blue whales on Earth.

Illustration by **Scott Smith**

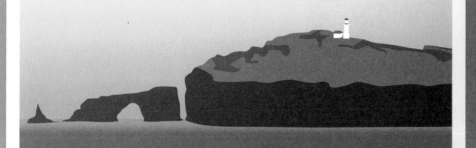

ISLE ROYALE NATIONAL PARK

Established: 1940 — Michigan

The largest wilderness area in Michigan, Isle Royale National Park sits in Lake Superior, on the border with Canada. The island was mined for copper by Native Americans, then by settlers in the 1840s, and then visited by tourists and entrepreneurs until the National Park was established in 1940, thanks largely to the work of a local journalist. Famous for its wolves and its moose, Isle Royale also features a number of shipwrecks in its waters due to its location on historic shipping routes.

Illustration by *Matt Brass*

MAMMOTH CAVE NATIONAL PARK

Established: 1941 — Kentucky

In 1797, the Houchin family became the first Europeans to discover the cave while hunting a bear. The cave was privately owned until controversy among competing owners inspired Kentucky citizens to successfully lobby for the creation of Mammoth Cave National Park in 1926. The park is named for its size—at 400 miles it is the longest known cave system in the world and twice the size of the second longest.

Illustration by *Philip Vetter*

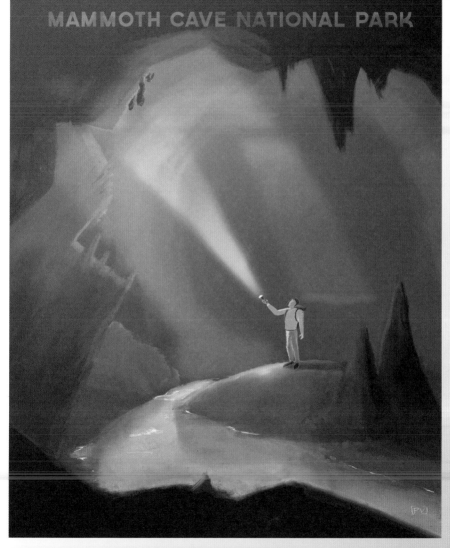

THEODORE ROOSEVELT NATIONAL PARK

Established: 1947 — North Dakota

Questing for adventure, 25-year-old Theodore Roosevelt came to this rugged part of
North Dakota to make a name for himself. He returned the following summer after the deaths
of his wife and his mother to start a ranch. Fifteen years after his death in 1919, the Civilian
Conservation Corps, a public work relief program that was part of Franklin D. Roosevelt's New
Deal, began work on the Roosevelt Recreation Demonstration Area in Theodore's beloved
badlands. It was later renamed to Theodore Roosevelt National Park in 1978.

Illustration by *Matt Brass*

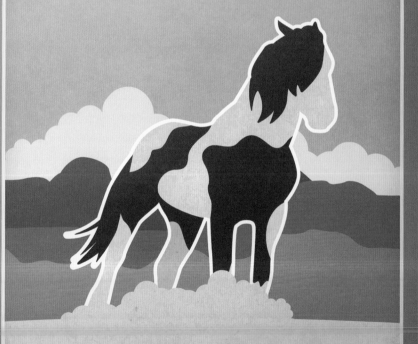

EVERGLADES NATIONAL PARK

Established: 1947 — Florida

The first national park to preserve an ecosystem rather than geographic features, Everglades National Park was established in 1934 to protect the largest mangrove forest in the Western Hemisphere from being drained for agriculture and developed for housing. The bill approving the creation of the park was passed in 1934, but funding was delayed by the Great Depression and the park did not open until 1947. Famous for its alligators, Everglades National Park is the largest national park east of the Mississippi river and the largest tropical wilderness in the country.

Illustration by *Megan Kissinger*

VIRGIN ISLANDS NATIONAL PARK

Established: 1956 — U.S. Virgin Islands

Beginning in the 1600s, the Virgin Islands were an international trading hub for sugar, rum, and cotton, until Denmark sold the islands to the U.S. in 1916. After World War II, when the islands served as military installations, a private citizen donated 5,000 acres on Saint John Island to the National Park Service. Later that year, Congress established Virgin Islands National Park. The park is known for its white sand beaches, scuba diving, and tropical beaches, including world famous Trunk Bay.

Illustration by *Liliya Moroz*

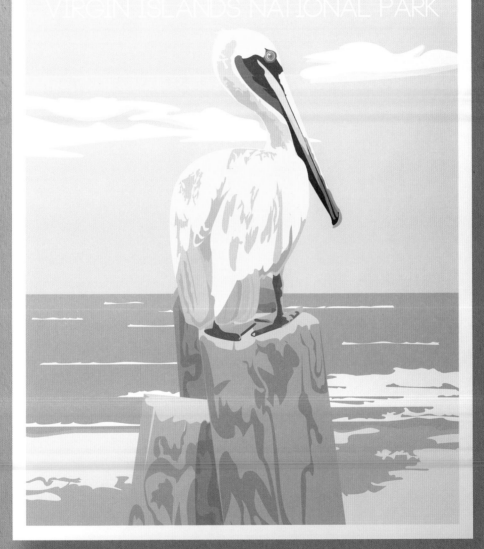

MONUMENT VALLEY NAVAJO TRIBAL PARK

Established: 1958 — Arizona/Utah

This area of the Colorado Plateau has been the setting of more Western movies than any other site in the country. Sandstone buttes rise up 1,000 feet or more above the valley floor, forged by winds and erosion over the last 50 million years and the distinctive East and West Mitten Buttes are nearly 2,000 feet tall. The Monument Valley Navajo Tribal Park was established by the Navajo Nation in 1958, and the Monument Valley area that surrounds it today sits near the Four Corners area, on the Arizona-Utah border.

Illustration by *Brixton Doyle*

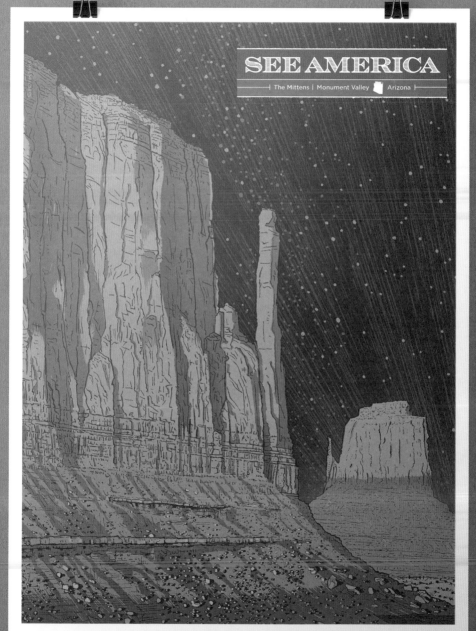

SEE AMERICA

The Mittens | Monument Valley | Arizona

CAPE COD NATIONAL SEASHORE

Established: 1961 — Arizona/Utah

After two months at sea, the passengers on the *Mayflower* landed at Plymouth Rock in Cape Cod on November 21, 1620, to build the first English settlement in America. Nearly 350 years later, Massachusetts-native President John F. Kennedy established Cape Cod National Seashore and opened up the Cape to new waves of visitors, who flocked to the park on the brand new American highway system. The population in Cape Cod now more than doubles each summer as vacationers head to the popular beachfronts of Massachusetts.

Illustration by *Susanne Lamb*

SEE AMERICA

CAPE COD NATIONAL SEASHORE
MASSACHUSETTS

FREDERICK DOUGLASS NATIONAL HISTORIC SITE

Established: 1962 — Washington, D.C.

Frederick Douglass was born a slave on a plantation in 1818 and escaped slavery as a teenager. He became a leading advocate for abolition and in 1876 was the first black person appointed to a federal position requiring Senate approval. After his death in 1895, his wife started the Frederick Douglass Memorial Association, which maintained his home in Washington, D.C., until 1962 when the National Park Service received the deed to restore and preserve the house and his legacy.

Illustration by *Kwesi Ferebee*

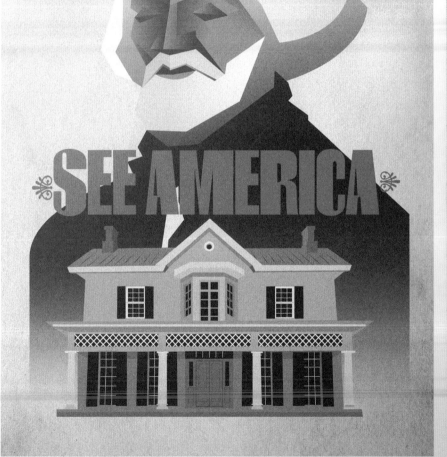

FREDERICK DOUGLASS NATIONAL HISTORIC SITE

SEE AMERICA

PETRIFIED FOREST NATIONAL PARK

Established: 1962 — Arizona

Over 250 million years ago, when the American continent was still part of the great landmass Pangaea, trees that fell began the long process of turning to stone and transforming into petrified wood. New railroads in the late 19th century expanded commercial interest in petrified wood, and in 1895, the Arizona Territorial Legislature began lobbying for national protection of this ancient forest. With the urging of John Muir and others, President Theodore Roosevelt established Petrified Forest National Monument in 1906. Congress made it a National Park in 1962, and President George W. Bush more than doubled the size of the park in 2004.

Illustration by **Brixton Doyle**

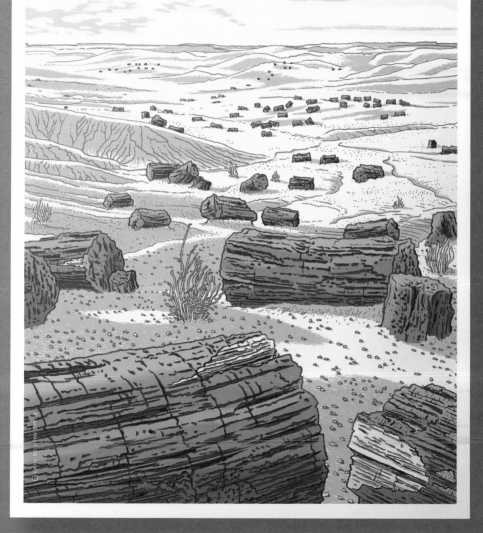

Petrified Forest National Park · Arizona

PICTURED ROCKS
NATIONAL LAKESHORE

Established: 1966 — Michigan

Established as America's first National Lakeshore in 1966, the name "Pictured Rocks" comes from the 15 miles of up to 200-foot-tall rock cliffs rising above Lake Superior. In 1874, the Au Sable Light Station was built on the southern shore of Lake Superior, the largest and deepest of the Great Lakes, rising 104 feet above lake level to help sailors navigate on shipping lanes crowded with traders and trappers. The lighthouse still operates today, and the lamp is now solar powered.

Illustration by **Mark Forton**

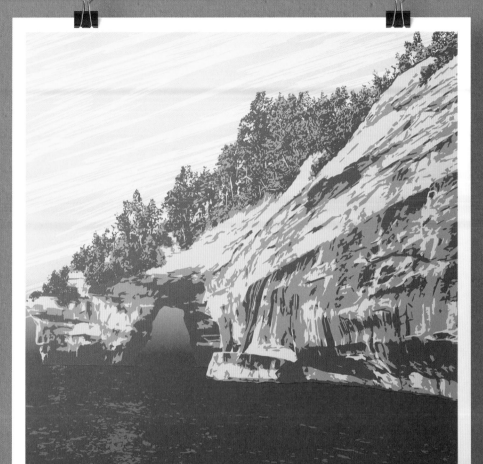

SEE AMERICA

PICTURED ROCKS NATIONAL LAKESHORE

PONY EXPRESS NATIONAL HISTORIC TRAIL

Established:1968—California/Colorado/Kansas/Missouri/Nebraska,/Nevada/Utah/Wyoming

It took only 10 days for mail to get from Missouri to California thanks to the Pony Express's relay system. In 1860, there were roughly 157 Pony Express stations spaced about 10 miles apart so riders could change horses and always gallop at maximum speed. The Pony Express lasted for only 18 months, until the invention of the telegraph and the outbreak of the Civil War put it out of business. While the exact routes used by the riders changed frequently, the Pony Express National Historic Trail features miles of original trail and Pony Express stations through eight states.

Illustration by *Lyla Paakkanen*

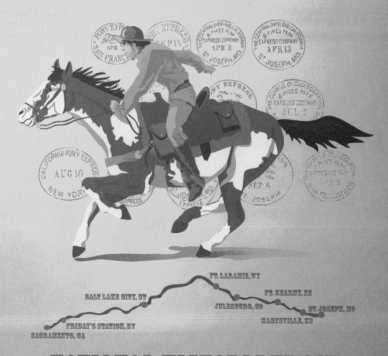

SEE AMERICA

PONY EXPRESS

FT. LARAMIE, WY

SALT LAKE CITY, UT

FT. KEARNY, NE

JULESBURG, CO

ST. JOSEPH, MO

MARYSVILLE, KS

FRIDAY'S STATION, NV

SACRAMENTO, CA

NATIONAL HISTORIC TRAIL

REDWOOD NATIONAL
AND STATE PARKS

Established: 1968 — California

After the California Gold Rush, many former miners turned their attention toward timber, and by the time Redwood National Park was established in 1968, 90 percent of the old-growth redwood trees had been cut down. When it was combined with three adjacent state parks in 1994, the new park protected nearly half of all the remaining coast redwoods, one of the largest species of trees on the planet. The park nestles 40 miles of coastline, and the fog from the sea provides nearly a quarter of the water the redwoods need.

Illustration by *Design by Goats*

SEE AMERICA
REDWOOD NATIONAL & STATE PARKS

APPALACHIAN NATIONAL SCENIC TRAIL

Established: 1968 — Connecticut/Georgia/Maine/Maryland/Massachusetts/New Hampshire/New Jersey/New York/North Carolina/Pennsylvania/Tennessee/Vermont/Virginia/West Virginia

Completed in 1937, the 2,000-mile-long Appalachian Trail was built by private citizens to connect rural farms and towns with cities through 14 states from Georgia to Maine. Nearly four million people hike some part of the trail every year, and ambitious hikers can walk the entire route, stopping at campsites spaced a day's hike apart. It became one of the first National Scenic Trails when it was designated in 1968, and unofficial extensions of the trail go as far south as Florida and as far north as Canada.

Illustration by ***Livia Veneziano***

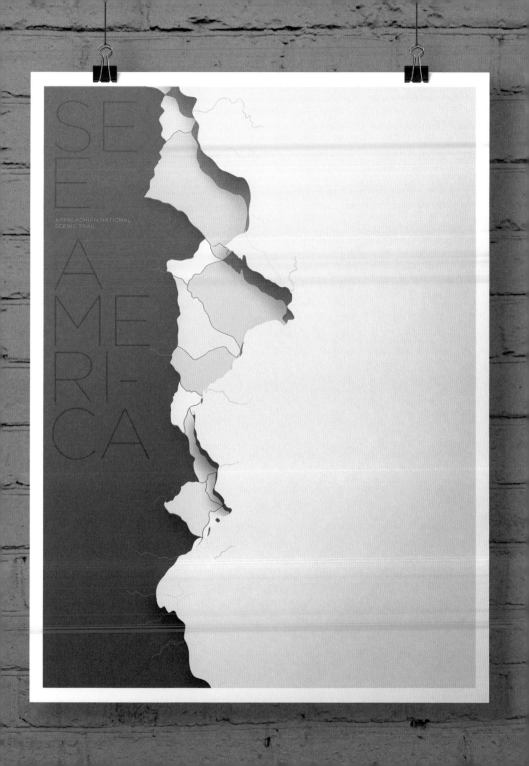

APOSTLE ISLANDS
NATIONAL LAKESHORE

Established: 1970 — Wisconsin

The 21 islands and shoreline that make up Apostle Islands National Lakeshore sit along the western edge of Lake Superior. Wilderness now covers the lighthouses, stone walls, and other structures built by the many former inhabitants of the islands, from Native American families to French fur trappers. With eight historic lighthouses on six different islands, Apostle Islands features more lighthouses than any other unit of the National Park Service.

Illustration by *Jamey Penney-Ritter*

SLEEPING BEAR DUNES NATIONAL LAKESHORE

Established 1970 — Michigan

Named after a Chippewa legend of a mother bear waiting for her cubs to swim across Lake Michigan, Sleeping Bear Dunes National Lakeshore was established in 1970 to protect America's "third coast," the Great Lakes. Ghost towns remain from the mining and logging communities built in the 1800s, when steamships would use the islands to resupply lumber for fuel. The park includes two large islands in Lake Michigan and 35 miles of coastline and is one of the most popular camping destinations in Michigan.

Illustration by *Esther Licata*

SLEEPING BEAR DUNES NATIONAL LAKESHORE, MI

VOYAGEURS NATIONAL PARK

Established: 1971 — Minnesota

The Minnesota Legislature first proposed a National Park in 1891, but it wasn't until 1971 that President Nixon signed a bill into law creating Voyageurs National Park. The park is named for the French-Canadian fur trappers, called "travellers," who charted the area between the United States and Canada on the Intercontinental Highway of the late 1700s. The park features exposed rocks that are 2.8 billion years old and encompasses 84,000 acres of water, making it a popular destination for kayaking, fishing, and boating.

Illustration by *Vikram Nongmaithem*

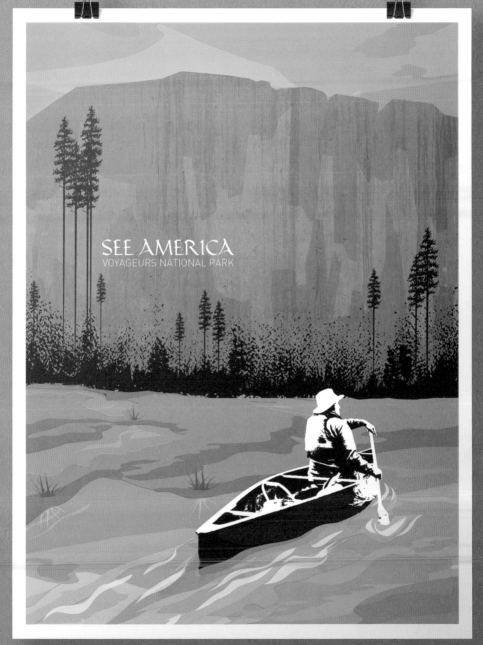

SEE AMERICA
VOYAGEURS NATIONAL PARK

POINT REYES NATIONAL SEASHORE

Established: 1972 — California

Separated from the rest of the U.S. by a rift in the San Andreas Fault, the beaches of the peninsula are some of the most pristine in the country. In 1962, local representatives won protection for the area, to prevent development from encroaching, when Congress created Point Reyes National Seashore. Home to elephant seals and migrating gray whales, Point Reyes is also where Sir Francis Drake landed in 1579, and over 120 village sites from the Coast Miwok Indians are still there today.

Illustration by *Jonathan Scheele*

SEE AMERICA

POINT REYES — NATIONAL SEASHORE

SCHEELE

GOLDEN GATE NATIONAL RECREATION AREA

Established: 1972 — California

One of the largest urban parks in the world, Golden Gate National Recreation Area encompasses 37 distinct park sites, 1,200 historic sites, and 19 separate ecosystems in Northern California, including Alcatraz, Muir Woods National Monument, China Beach, and the Presidio of San Francisco. Golden Gate National Recreation Area was created in 1972, and the National Park Service has been incorporating new sites ever since, including Fort Funston, Sutro Baths, and Crissy Field. It is the second-most visited place in the National Park Service, with more than sixteen million visitors every year—more than Yosemite, Yellowstone, Grand Canyon, and Glacier National Parks combined.

Illustration by *David Hays*

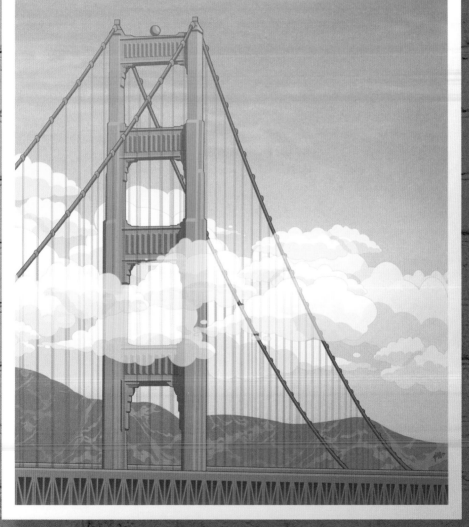

OBED WILD AND SCENIC RIVER

Established: 1976 — Tennessee

Thanks in part to its remote location and the poor farming soil surrounding it, the Obed River looks much today as it did for the Native Americans of the Cumberland Plateau and later for the log cabin pioneers who came after Tennessee became a state in 1796. As new railroads brought more industrial activity to the area, concerned citizens lobbied for legal protection, and on October 12, 1976, their efforts succeeded when the area became a part of the National Park Service. The river maintains its status as one of the most famous and most difficult whitewater kayaking and rafting sites in the country.

Illustration by *Philip Vetter*

CONGAREE NATIONAL PARK

Established: 1976 — South Carolina

Spanish explorer Hernando De Soto was captivated by the drama of the area when he visited in 1540, and settlers worked to develop the area ever since. Accessibility into the floodplain had previously limited logging efforts, but when timber prices rose in the late 1960s, calls for protection of the Congaree grew. In 1976, Congress created Congaree National Monument, which became Congaree National Park in 2003. The park today preserves the oldest old-growth bottomland hardwood forest left in the United States.

Illustration by *Vikram Nongmaithem*

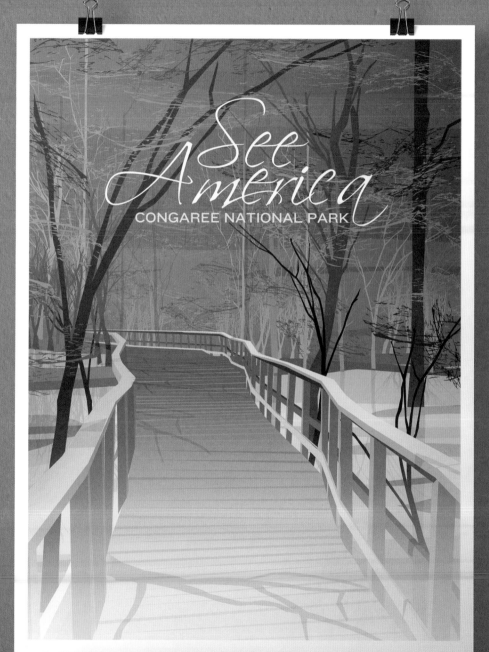

See America

CONGAREE NATIONAL PARK

LEWIS AND CLARK NATIONAL HISTORIC TRAIL

Established: 1978 — Idaho/Illinois/Iowa/Kansas/Missouri/Montana/Nebraska/North Dakota/Oregon/South Dakota/Washington

In May 1804, Lewis and Clark set out to discover the American continent on what would become one of our nation's most famous expeditions. In 1978, when Congress created the designation "National Historic Trail," the Lewis and Clark National Historic Trail became one of the first, covering 11 states from the Plains to the Pacific. At 3,700 miles long, Lewis and Clark is the second-largest national historic trail in the country.

Illustration by *Michael Czerniawski*

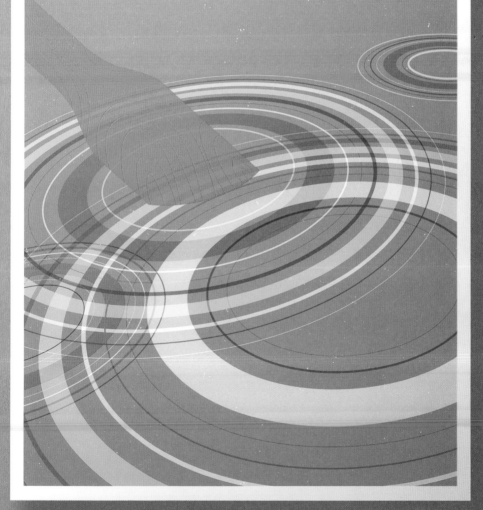

SEE AMERICA

LEWIS & CLARK NATIONAL HISTORIC TRAIL

NEW RIVER GORGE NATIONAL RIVER

Established: 1978 — West Virginia

The completion of a new railroad in 1873 brought new homesteaders and farmers and the timber industry to the area around one of the continent's oldest rivers. To preserve the longest and deepest river gorge in the Appalachian Mountains, in 1978, President Jimmy Carter protected 53 miles of free-flowing river with the creation of New River Gorge National River. Today the park is one of the most popular rock-climbing destinations in the country, as well as a hotspot for whitewater rafting, fishing, and sightings of the peregrine falcon.

Illustration by *Shane Henderson*

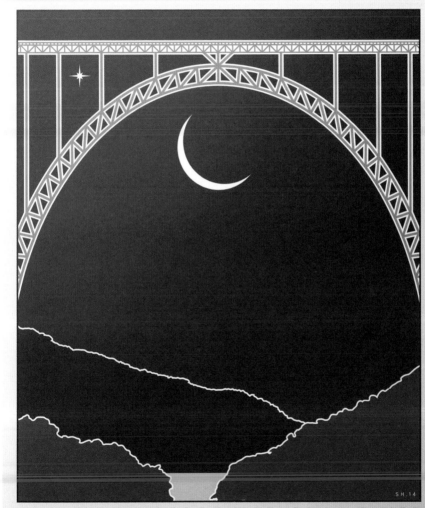

SEE AMERICA

NEW RIVER GORGE NATIONAL RIVER

SH.14

SAN ANTONIO MISSIONS NATIONAL HISTORICAL PARK

Established: 1983 — Texas

When the Spanish controlled the Southwest in the 16th through 19th centuries, they created a series of Catholic frontier missions in what is Texas today to protect against Apache attacks and to spread Christianity. In 1975, 84 different historical sites were designated as the Mission Parkway, becoming San Antonio Missions National Historical Park in 1983. While not part of this park, one of the San Antonio missions, the Alamo, played a pivotal role in the history of Texas, and some of the missions still house active parishes today.

Illustration by *Joshua Sierra*

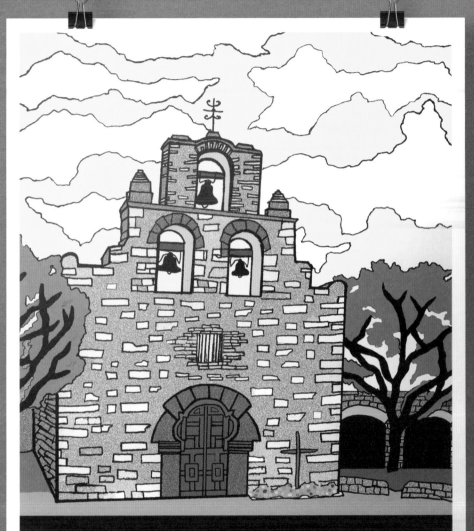

SEE AMERICA

SAN ANTONIO MISSIONS

NATIONAL HISTORICAL PARK

NATIONAL PARK OF AMERICAN SAMOA

Established: 1988 — American Samoa

After years of dispute, in 1899, Germany and the U.S. agreed to split control of the Samoan Islands in the South Pacific. In the half century that followed, American Samoa served as a vital military installation, a legacy evident today in the fact that American Samoa has a higher military enlistment rate than any other U.S. state or territory. The park was established in 1988 under a lease with Samoan village councils, and today National Park of American Samoa is our only national park south of the equator.

Illustration by *Roberlan Borges*

MANZANAR NATIONAL HISTORIC SITE

Established: 1992 — California

Spanish for "apple orchard," the town of Manzanar was a quiet farming town in California's Owens Valley until February 2, 1942. On that day, President Franklin D. Roosevelt signed Executive Order 9066, two months after the Japanese attack on Pearl Harbor. The order authorized the War Department to "solve the Japanese problem" on the West Coast by relocating between 110,000 and 120,000 Japanese Americans, two thirds of them born in America, to 10 military "relocation centers." The camp was closed in 1945. At the urging of activists like Sue Kunitomi Embrey, who believed it was crucial for the country to "[make] amends for the wrongs it has committed," Manzanar was designated a California Historical Landmark in 1972 and a National Historic Site in 1992.

Illustration by *Siamee Yang*

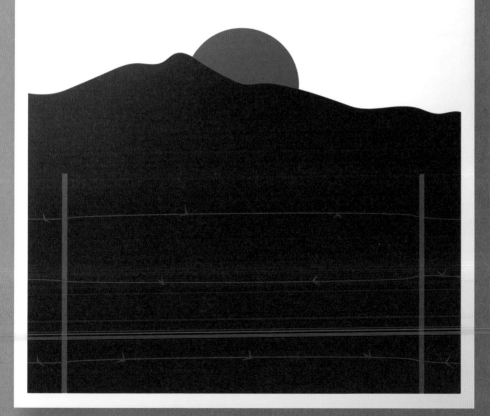

BIG SUR, MONTEREY BAY NATIONAL MARINE SANCTUARY

Established: 1992 — California

After California became a U.S. territory with the end of the Mexican-American war, American settlers mixed the Spanish name "El Sur Grande" ("The Big South") with English, giving the wilderness south of Monterey its current name. The construction of Highway 1 along the California coast in the 1930s opened the 90 miles of coastline between Monterey and San Luis Obispo to visitors, including a wave of bohemians like Jack Kerouac and Hunter S. Thompson. The 1969 Santa Barbara oil spill led to increasing public calls for protection of the area, and in 1992, Congress created Monterey Bay National Marine Sanctuary, now the largest of the 13 national marine sanctuaries.

Illustration by *Jon Briggs*

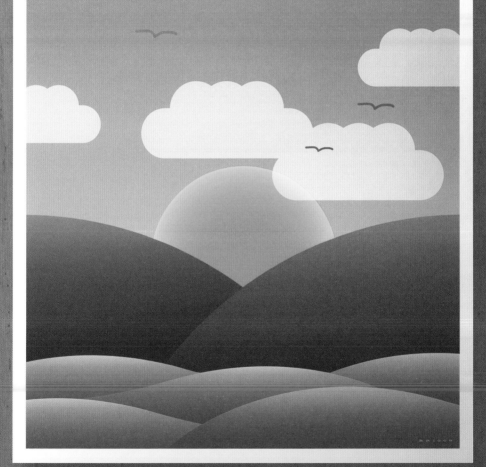

NEW ORLEANS JAZZ NATIONAL HISTORICAL PARK

Established: 1994 — Lousiana

In the mid-18th century, "Congo Square" in New Orleans was one of only two areas in the country where African Americans were allowed to openly sing and dance. In 1917, the Original Dixieland Jazz Band made the first jazz recording, and helped establish the Tremé neighborhood of New Orleans near the French Quarter as the hub for America's music. After Congress designated jazz music as "a rare and valuable national American treasure" in 1987, the park was established in 1994 to protect this cultural resource for future generations.

Illustration by *Cecelia Mattera*

BOSTON HARBOR ISLANDS NATIONAL RECREATION AREA

Established: 1996 — Massachusetts

On Little Brewster Island, one of the 34 islands that make up Boston Harbor Islands National Recreation Area, sits the oldest lighthouse site in the country, Boston Light, which was constructed in 1716. The first vocational school in the country was built on Thompson Island in 1833, and Alexander Stephens, the Vice President of the Confederacy, was held in a Union prison in the harbor during the Civil War. Visitors today come on ferries from Long Wharf; named in 1710, it is the longest continuously operating wharf in the country.

Illustration by *Liz Cook*

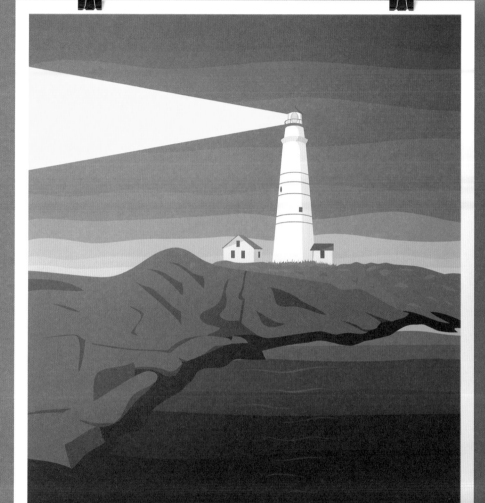

SEE AMERICA

BOSTON HARBOR ISLANDS NATIONAL PARK AREA

CALIFORNIA COASTAL
NATIONAL MONUMENT

Established: 2000 — California

In 1930, President Hoover signed the first legislation protecting the California coastline, and in 2000, President Bill Clinton created California Coastal National Monument to increase protection for the "islands, rocks, exposed reefs, and pinnacles above mean high tide within 12 nautical miles of the shoreline of the State of California." The area is home to hundreds of thousands of seabirds and marine mammals, and is one of the most viewed national monuments in the country.

Illustration by *Cabbage Creative*

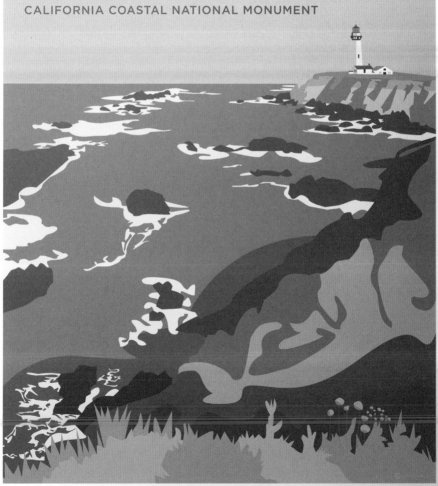

VERMILION CLIFFS
NATIONAL MONUMENT

Established: 2000 — Arizona

Formed by millions of years of erosion, these richly colored rocks have attracted humans for 12,000 years. Mormons traveled the historic "Honeymoon Trail" wagon route beneath the cliffs on their way to get married at the temple at St. George, Utah. The remote area boasts more sandstone than anywhere else on earth. Flash floods carved the most famous feature, the Wave, through petrified sandstone and iron deposits, creating a magical rainbow of colors in the rock.

Illustration by *Justin Beaulieu*

AFRICAN BURIAL GROUND
NATIONAL MONUMENT

Established: 2006 — New York

Originally called "Negroes Burial Ground" when it was a cemetery for more than 400 free and enslaved blacks from 1712 to 1794, the site was rediscovered by an archeological excavation planning a new federal office building in 1991. The initial construction was stopped, and a monument was built in its place in Lower Manhattan, between City Hall and the federal courts. At the dedication of African Burial Ground National Monument, poet Maya Angelou said, "It is imperative that each of us knows that we own this country because it's already been paid for."

Illustration by *Kwesi Ferebee*

NIAGARA FALLS NATIONAL HERITAGE AREA

Established: 2008 — New York

The birthplace of modern hydroelectric power and the oldest state park in the country, the Niagara Falls National Heritage Area features the 165 foot-drop of Niagara Falls with the highest flow rate of any waterfall in the world. From the War of 1812, to the Civil War, to the Underground Railroad, the area has played a pivotal part in our nation's history, and the advent of the automobile made it much easier for residents of the region to visit. To protect these natural and cultural landmarks, President Obama designated them as a national heritage area in 2008.

Illustration by *Brixton Doyle*

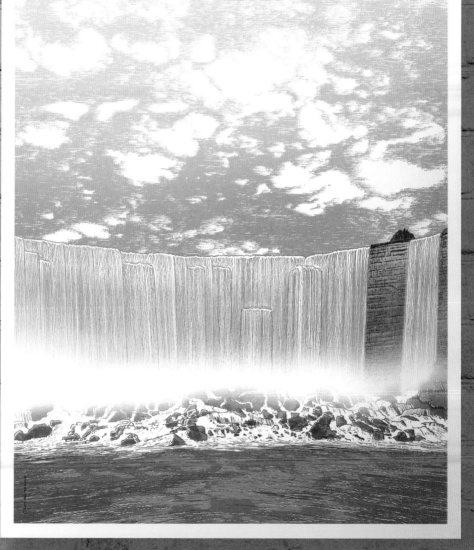

MARTIN LUTHER KING, JR. MEMORIAL

Established: 2011 — Washington, D.C.

Nearly 50 years after Dr. Martin Luther King, Jr. gave his "I Have a Dream" speech from the steps of the Lincoln Memorial, the Martin Luther King, Jr. Memorial opened as the first monument to an African American in Washington, D.C., on the National Mall. Dr. King's fraternity, Alpha Phi Alpha, began working toward a memorial after his assassination, and their efforts gained new momentum when Congress designated Dr. King's birthday a federal holiday in 1986. The memorial sits between the Lincoln Memorial and the Jefferson Memorial at 1964 Independence Ave., an address that honors Dr. King's role in the passage of the 1964 Civil Rights Act.

Illustration by *Brixton Doyle*

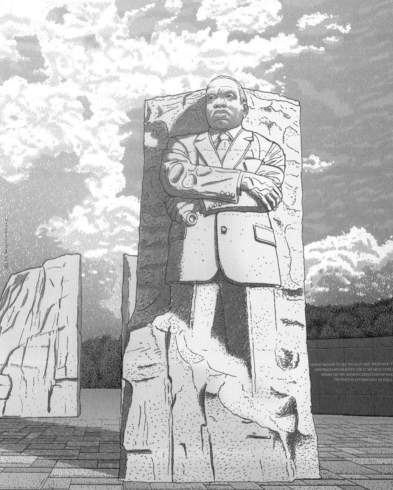

IT IS NOT ENOUGH TO SAY "WE MUST NOT WAGE WAR," IT IS NECESSARY TO
LOVE PEACE AND SACRIFICE FOR IT. WE MUST CONCENTRATE NOT
MERELY ON THE NEGATIVE EXPULSION OF WAR, BUT ON
THE POSITIVE AFFIRMATION OF PEACE.

SEE AMERICA

Martin Luther King, Jr. Memorial Washington D.C.

HARRIET TUBMAN UNDERGROUND RAILROAD NATIONAL MONUMENT

Established: 2013 — Maryland

Harriet Tubman escaped from slavery in 1849. Over the next 10 years, she travelled back from Philadelphia to Maryland 13 times to rescue 70 people through her network of safe houses and her knowledge of the stars, earning her the nickname "Moses." After serving as a spy, a scout, a cook, and a nurse during the Civil War, she dedicated her life to civil rights and women's suffrage. In 2013, the 100th anniversary of her death, President Barack Obama established this national monument to preserve her legacy and honor her life in Maryland.

Illustration by *Daria Theodora*

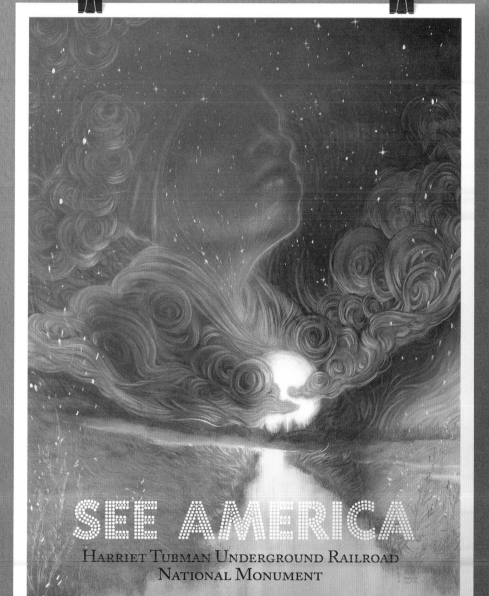

SEE AMERICA

HARRIET TUBMAN UNDERGROUND RAILROAD
NATIONAL MONUMENT

PULLMAN NATIONAL MONUMENT

Established: 2015 — Illinois

In 1879, railroad magnate George Pullman bought 4,000 acres of land south of Chicago
to develop a company town for his employees, many of them newly emancipated African
Americans. When the Pullman Company lowered wages without lowering rents, the workers
launched what would become a nationwide rail strike—resulting in the birth of the modern labor
movement and the inspiration for Labor Day.

Illustration by *Carmela La Gamba Bode*

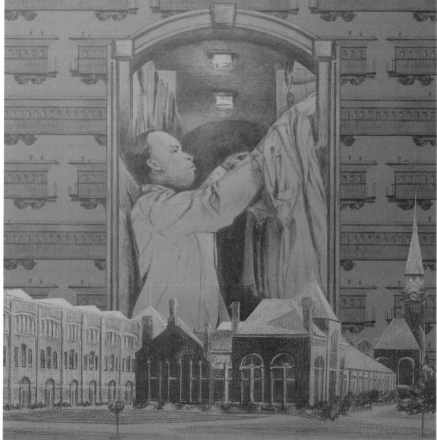

SEE AMERICA

Pullman National Monument

ARTIST BIOGRAPHIES

Aaron Bates *(Big Bend NP)*
Aaron is a photographer based in Austin, Texas. He is an advocate for conservation and a supporter of our national parks, state parks, and all wild places in between. Aaron enjoys connecting people to the great outdoors and encourages the preservation of what is ours through his photography.

Adam S. Doyle *(Joshua Tree NP)*
Adam is an artist and illustrator, creating images that invigorate our connection to our natural world, our humanity, and our shared story. His formative experience with the majesty of Joshua Tree was during his first cross-country drive from Boston to Los Angeles. He's since lived in multiple cities in the States and overseas.

Alyssa Winans *(Yosemite NP, Hawai'i Volcanoes NP, and Carlsbad NP)*
Alyssa is a San Francisco Bay Area freelance illustrator and game artist, as well as a graduate of the Rhode Island School of Design. She originally hails from the beautiful Midwest and has long cultivated a love for historical American landscape painting as well as painting landscapes herself.

Annie Riker *(Chaco Culture NHP)*
Annie has considered herself an artist and designer ever since she was old enough to hold a paintbrush. In her spare time, you'll find her outside—exploring, sketching, and taking pictures. She is the art director for the National Parks Conservation Association in Washington D.C.

Brandon Kish *(Washington Monument NM)*
Brandon is a Michigan-based freelance graphic designer and artist. Traveling through America with his uncle helped him gain a great appreciation for the beauty and vastness of American national parks and monuments. He cherishes the national parks he has visited and yearns for those he has not yet been to.

Braulio Amado *(Death Valley NP)*
Braulio is a Portuguese graphic designer living and working in New York City.

Brixton Doyle *(Yellowstone NP, Devils Tower NM, Organ Pipe Cactus NM, Petrified Forest NP, Niagara Falls NHA, Monument Valley, and Martin Luther King NM)*
Brixton is an Illustrator and designer from Brooklyn, New York. Following the long line of educators in his family, he has also taught graphic design and typography at the Parsons School

of Design for the past twenty years. He's traversed the U.S. numerous times learning about our historic sites and the natural wonders of our national parks.

Carmela La Gamba Bode *(Pullman NP)*
Carmela is an artist and educator on Long Island, New York. After graduating from the Cooper Union School of Art, she worked as a calligrapher and graphic designer. Later, she attended Hunter College for a masters in education and currently teaches elementary and secondary level art.

Cecelia Mattera *(New Orleans Jazz NHP)*
Cecelia is a Long Island native. As a child, her uncle gave her a paint set and arts-and-craft gifts from his travels, instilling a passion for different cultures and places. She received her masters in Education from Stony Brook, and has been an arts educator for over 30 years at Lindenhurst High School.

Corbet Curfman *(Olympic NP)*
Since graduating from Rhode Island School of Design in 1996 with a BFA in illustration, Corbet has been creating award-winning work in design and advertising. Currently, he is an Associate Creative Director at Wunderman Seattle. Corbet is inspired every day living in the Pacific Northwest, surrounded by some of the most engaging landscapes in the world.

Daisy Patton *(Rocky Mountain NP)*
Located in Denver, Colorado, Daisy Patton has lived all across the continental United States. This familiarity with our country's varied regions has greatly influenced her work, including projects on Death Valley and permafrost in Colorado. Daisy completed her MFA at Tufts University/School of the Museum of Fine Arts, Boston.

Daria Theodora *(Harriet Tubman Underground Railroad NM)*
Daria is an illustrator residing in the Greater Boston area. Her mediums of choice are ink, watercolor, and gouache. She often enjoys an afternoon walk on the Alewife Brook bike paths or biking on Deer Island after a long day of drawing. When time permits, she likes to go hiking and observe nature.

ARTIST BIOGRAPHIES

Darrell Stevens *(Dinosaur NM)*
Originally from England, Darrell is a professional graphic designer and artist now living in Amherst, New York. An avid hiker and bird watcher, he finds inspiration in the simple beauty of the natural environment, which helps shape his approach to design.

David Garcia *(Statue of Liberty NM)*
David is an urban illustrator born in Quito, Ecuador. Seeking new experiences, he decided to move to New York in 2003. He's inspired by street art, pluriculturalism, music, and urban culture around the world. He currently runs Chacana NYC, a line of accessories and clothing designed in New York and handmade by South American artisans.

David Hays *(Golden Gate NRA)*
David is a ninth-generation Californian and advertising creative director based in Los Angeles. David has created numerous award-winning campaigns for the largest brands in the world, but he also finds gratification in putting his skillset to work as an activist for causes he feels passionately about, such as ecological preservation.

Don Henderson *(Allegheny NF and Statue of Liberty NM)*
Don is an Irish-American graphic designer and illustrator from Pittsburgh. Together with his son Shane, they are Henderson Graphic Design & Illustration. HGDI specializes in logo design, branding, and illustration. Don is also the president and founder of the New Kensington Camera Club and f-Stop ALS.

Esther Licata *(Sleeping Bear Dunes NL)*
Esther Licata is an artist who lives and works in the Detroit area. She is in her final year studying illustration at the College for Creative Studies. Born and raised in Michigan, she has always loved the Great Lakes and the natural beauty the state has to offer.

Frank Cervantez *(Antietam NB)*
Frank is currently living in Southern California and studying Industrial Design at the Art Institute. Growing up, Frank was an active member of the Boy Scouts of America and achieved the rank of Eagle Scout. He shares his love of nature through his art and design.

Hanna Norris *(Saguaro NP)*
Hanna Norris is a graphic designer in Phoenix. After emigrating from Poland to Arizona, Hanna

and her family spent countless summers exploring the deserts of the Southwest, falling in love with the foreign landscape and exploring the parks, big and small, that make up her new home.

Jamey Penney-Ritter *(Apostle Islands NL)*
Jamey lives on the south shore of Lake Superior, within sight of the Apostle Islands. She is a graphic designer, illustrator, and photographer.

J. D. Reeves *(Grand Canyon NP)*
J. D. is a freelance graphic designer living and working in Norman, Oklahoma. Growing up in rural eastern Oklahoma, he developed a deep appreciation for woods and lakes. He loves the diversity of the American landscape and believes that getting back to nature is the best way to feel inspired.

Jenn Brigham *(Denali NPP)*
Jenn is an art director currently living in Los Angeles, California. The varied terrain and beauty found within the national parks system inspires her work. She photographs everything from landscapes to flowers, which informs her colorful illustrations.

Jessica Gerlach *(Saguaro NP)*
Jessica is a designer and illustrator currently living in Cedar City, Utah, where she teaches design at Southern Utah University. She is committed to making designs that address issues of social and environmental relevance. She is passionate about design, science, letterpress, and the natural beauty of the American landscape.

Jon Briggs *(Big Sur, Monterey Bay NMS)*
Jon is a graphic designer, art director, and illustrator living and working in Oceanside, California. He grew up bodysurfing and snorkeling in the waters off Southern California and draws inspiration daily from nature and the environment.

Jon Cain *(Great Smoky Mountains NP and Blue Ridge NP)*
Jon is an award-winning associate creative director for a North Carolina–based advertising agency. He attended East Carolina University, where he received two BFAs in painting and photography. His love of art has kept him traveling and exploring all the great wonders of the outdoors.

ARTIST BIOGRAPHIES

Jonathan Scheele *(Grand Teton NP and Point Reyes NS)*
Jonathan is the owner of Open Sky Ideas and lives in Nashville, Tennessee, with his wife and three children. From childhood trips across America, to working at Yellowstone National Park in the summer of 1995 (and meeting his wife), to recent trips west, Jonathan gains his inspiration from the amazing American landscape.

Joshua Sierra *(Katmai NPP and San Antonio Missions NHP)*
Joshua is a freelance artist based out of Los Angeles, California. When he is not trying to save the world from the perils of visual boredom through illustration and printmaking, he is waging urban warfare on drab exteriors and mundane landscapes through murals, outdoor paintings, and miscellaneous street art.

Justin Beaulieu *(Vermilion Cliffs NM)*
Justin, a designer from Performance Racing Industry in Laguna Beach, has spent his whole life living in action and the great outdoors. From rock climbing and cliff diving to extreme sports and precarious adventures, he strives to go where most would not think of venturing.

Kailee McMurran and Duke Stebbins, Design by Goats *(Redwood NSP)*
Design by Goats is a creative duo based in Portland, Oregon. Duke and Kailee are either exploring the infinite possibilities of the creative world or indulging in the natural wonders of the American West and beyond!

Kendall Nelson *(Arches NP)*
Kendall lives in sunny Valencia, California, with his wife and two sons. He has always found artistic inspiration in nature—from the red rocks of his home state of Utah to the giant sequoia of his new home in California.

Kwesi Ferebee *(Frederick Douglass NHS and African Burial Ground NM)*
Kwesi is a graphic designer for Design Action Collective in Oakland, California. The Frederick Douglass and African Burial Grounds illustrations speak to honoring the fortitude and courage of those individuals who he regards as "ancestors whose existence serves as a powerful example of how Black lives truly matter."

Liliya Moroz *(Virgin Islands NP)*
Liliya was born in Ukraine and raised in the Pacific Northwest since she was eight years old.

She absolutely loves the PNW life. The mountains, lakes, rivers, ocean, trees, rain, and sun: every sight and season inspires creativity, adventure, and the desire to explore. She loves hiking, sunsets, and photography.

Livia Veneziano *(Appalachian NST)*

Livia is a UX designer, hobby photographer, and illustrator based in Brooklyn, New York. She is an alum of the Rhode Island School of Design and focuses on creating experiences for digital education and communication tools.

Liz Cook *(Boston Harbor Islands NRA)*

Liz is a Boston-based creator and musician. In her current position at Boston Harbor Island Alliance, Liz organizes public programs and events in the park and also serves as in-house designer. In her free time, she continually seeks new landscapes to capture and explore.

Luis Prado *(Sequoia and Kings Canyon NP, Zion NP, Lincoln Memorial NM, Ellis Island NM, Wright Brothers NM, and Dry Tortugas NP)*

Luis is an Argentine-born graphic designer. He loves visual communications and coffee. Since childhood he's had a connection to the outdoors—playing soccer, camping, and enjoying a walk at a park. In fact, he proposed to his wife at Tilden Park near Berkeley, California. She said no, but that's another story.

Lyla Paakkanen *(Pony Express NHT)*

Lyla lives in Sacramento, California, where the Pony Express ended its route. She is a freelance artist and illustrator, took classes in Communications Design at UCLA, and has a master's degree in art from CSUN. She taught art at five colleges and has won many awards in California and Colorado for her work.

Mark Forton *(Pictured Rocks NL)*

Mark is a lifetime advocate of the environment. He blends the obvious and real with technology in his art. His use of fine art and graphic design reminds us of the chaos and tranquility of both the natural and artificial, digital worlds.

ARTIST BIOGRAPHIES

Marlena Buczek Smith *(Statue of Liberty NM)*
Marlena moved to the United States from Poland in the early '90s. Her body of work includes posters, commercial graphic design, and paintings. Her posters have been printed in various publications and exhibited globally in countries which include the U.S., Germany, Italy, and Russia.

Matt Brass *(Gettysburg NMP, Glacier NP, Grand Canyon NP, Badlands NP, Isle Royale NP, and Theodore Roosevelt NP)*
Matt is a creative director for an ad agency specializing in the sustainability space. His background includes work for many national clients in the areas of campaign development, film production, and art direction. After launching a *Huffington Post* travel feature, Matt has begun applying his illustrative skills to a collection of prints entitled Ranger Series.

Megan Kissinger *(Everglades NP)*
Megan is an acrylic painter and artist who is interested in conservation. She depicts the art of southern North America in all its wild glory in order to show viewers the beautiful natural world that is disappearing before their very eyes.

Michael Czerniawski *(Lewis and Clark NHT)*
Michael is an educator and illustrator who lives just outside of Chicago. Growing up with a forest practically at his front door, Michael made the woods his playground and continues to be inspired by nature.

Monica Alisse *(Yosemite NP)*
Monica is a graphic designer and illustrator who graduated from Rhode Island School of Design in 2009. She loves to travel and believes her environment stimulates her to produce something inspiring and new. She enjoys using watercolor when illustrating landscapes. The medium rewards the artist with unexpected results, and all that's left is intuition.

Naomi Sloman *(Yosemite NP)*
Naomi is an illustrator from Brighton, England, who loves animals and nature—especially mountains. She fell in love with Yosemite a few years ago and is looking forward to a road trip through the United States next year, taking in as many more of the national parks as possible.

Nikkolas Smith *(Yosemite NP)*
Nikkolas is an architect and concept artist from Houston, Texas, by way of Hampton University

in Virginia. He works in the field of theme park design and freelance concept art in Burbank, California. A great emphasis of Nikkolas's everyday role is centered around recreating the natural beauty of our national parks into themed lands for millions to enjoy.

Philip Vetter (*Mammoth Cave NP and Obed Wild and Scenic River*)
Philip is a freelance motion designer and illustrator who calls Southern Indiana home. He loves to be outdoors with his family and enjoys hiking, camping, backpacking, and trail running whenever possible. Creatively, Philip continues to be inspired by the ever-changing beauty of the Midwest.

Roberlan Borges (*American Samoa NP, Haleakalā NP and Saguaro NP*)
Roberlan is a digital artist and illustrator from Brazil, living in Vitória, Espírito Santo, with his wife and three daughters. His inspiration to work on the national parks posters and on the *See America* project came from the references he has from movies and music.

Scott Smith (*Channel Islands NP*)
Scott is a web designer and photographer born and raised in Southern California. He has been hiking and camping since he was a kid and is thankful for the many national parks and monuments he's experienced.

Shane Henderson (*Statue of Liberty NM, Jefferson NEM, and New River Gorge NR*)
Shane is a graphic designer, photographer and illustrator from Pittsburgh who owns and operates his own design studio with his father, Don Henderson. His love for the beauty of the American landscape, including his native Pennsylvania, can be found in much of his photography and art.

Shayna Roosevelt (*Muir Woods NM*)
Shayna is a native Californian artist and illustrator who designs textile patterns and writes for several nationally recognized blogs. She is inspired by her West Coast roots and the vivid colors of the East Coast. She lives with her husband, their two children, and a wild pup in Connecticut.

Siamee Yang (*Manzanar NHS*)
Siamee is a graphic designer who lives in Orange County, California, with her two dachshunds, Mae and Lucy. Born in a refugee camp and raised by a single mother who fled to the U.S. during the Vietnam War, Siamee's art is heavily influenced by the stories of immigrants and their journeys pursuing the American dream.

ARTIST BIOGRAPHIES

Susanne Lamb (*Cape Cod NS*)
Susanne is an illustrator, print designer, and writer living in Brooklyn. Since graduating from the Rhode Island School of Design, she has been creating lots of prints for women's sleepwear, writing and illustrating children's books, and escaping the city for trips into nature.

Tim Kapustka, Cabbage Creative (*California Coastal NM*)
Run by Michigan-born designer Tim, Cabbage Creative is a Durango, Colorado–based graphic design firm. Whether it's the mountains of Southwest Colorado or the forests of his home state, Tim has always counted nature among his biggest influences.

Vanessa Rosales (*Mount Rainier NP*)
Vanessa is a freelance graphic designer and illustrator currently living in Long Beach, California. In her free time, she loves visiting national parks. She was inspired to do her illustration when her friend Allan Hu climbed Mount Rainier. She dedicates this illustration to him.

Vikram Nongmaithem (*Voyageurs NP and Congaree NP*)
Vikram was born in a small town called Kakching, Manipur, located in the northeastern part of India. He is a designer who loves making graphic works. Vikram is now located in Delhi and working as an assistant art director at *Tehelka* magazine. He's never left India but had a great time taking part in this project.

Wedha Abdul Rasyid (*Mount Rushmore NM*)
Wedha is a 64-year-old illustrator and graphic designer from Jakarta, Indonesia. The style used for his Mount Rushmore design is his own approach called Wedha's Pop Art Portrait.

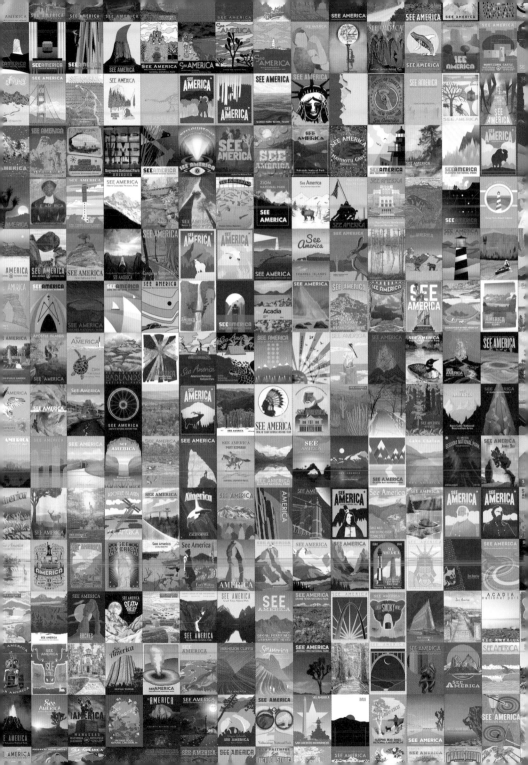

ACKNOWLEDGMENTS

Thank you to Chronicle Books; Kati Schmidt and everyone at the National Parks Conservation Association; Corey Ford, Lara Ortiz-Luis, and the Matter community; the Department of the Interior Museum; Christie George; and the Franklin D. Roosevelt Presidential Library and Museum for all your help and support in reviving the legacy of *See America*. Thank you to the Library of Congress, Geography and Map Division, and the U.S. Geological Survey for the historic maps used in the book.

Special thanks to Perry Wheeler, without whom *See America* would never have happened; Wynn Rankin, without whom this book would never have happened; the Perry-Zuckers, the Slavkins, Erin McNichol, and Jen Schwartz for their support.

Finally, thanks to all the artists who have submitted work to Creative Action Network campaigns; your talents and passions are at the heart of everything, and none of this would be possible without you.

ABOUT CREATIVE ACTION NETWORK

Creative Action Network (CAN) is a global community of artists and designers, harnessing their talents for good. CAN crowdsources creativity for causes, collecting work from thousands of passionate artists and designers around the world, and making that work available as prints, apparel, publications, and more to support their artists and the causes they care about. CAN has worked with organizations like the National Parks Conservation Association, New York Public Library, Patagonia, the White House, and others, generating a library of thousands of pieces of original, meaningful, visual work.

Cofounders Aaron Perry-Zucker and Max Slavkin, friends since preschool, have been building the CAN community since 2008, inspired by a shared admiration for the art projects of the Works Progress Administration and a belief in the power of creative communities.

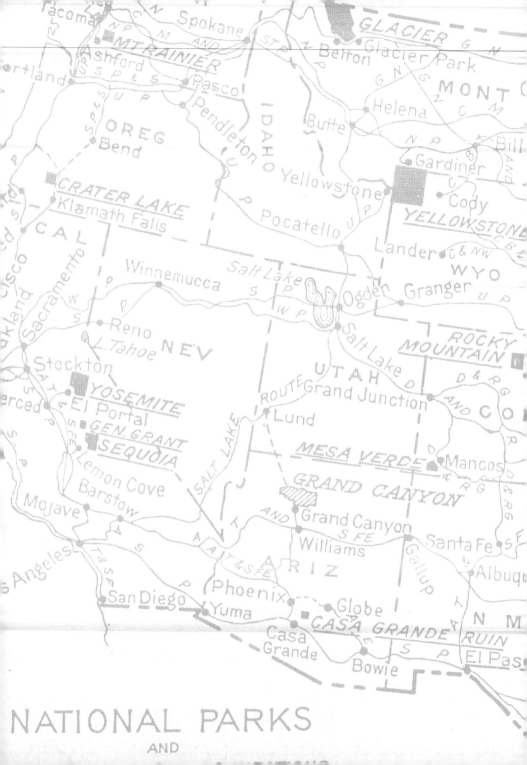

NATIONAL PARKS

AND

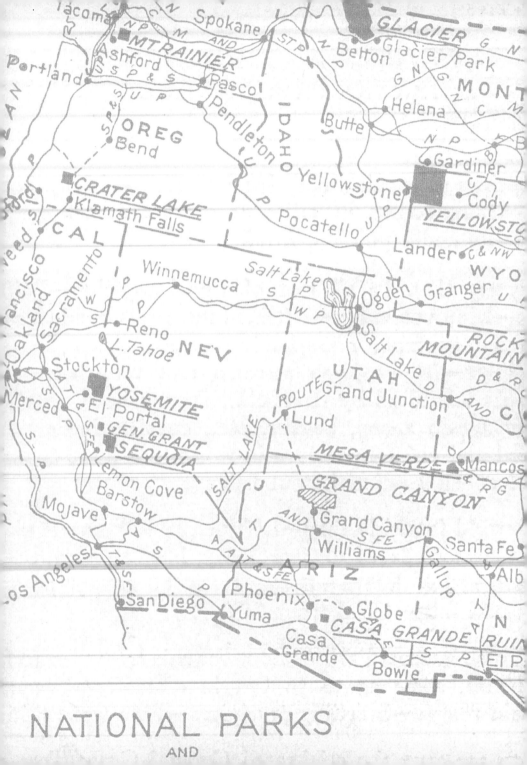

NATIONAL PARKS
AND